Legend, Myth, and Magic
in the Image of the Artist

Ernst Kris was a psychoanalyst who wrote on
a wide variety of subjects, including art. *Otto
Kurz* was librarian of the Warburg Institute
in London.

Legend, Myth, and Magic in the Image of the Artist

A Historical Experiment

Ernst Kris and Otto Kurz

Preface by E. H. Gombrich

New Haven and London
Yale University Press
1979

This book is based on *Die Legende vom Künsteer: Ein
historischer Versuch*, published in 1934 (Vienna:
Krystall Verlag). The English translation was
prepared by Alastair Laing and revised by
Lottie M. Newman. Additions to the original text
were made by Otto Kurz and are printed as
footnotes or in brackets in the text.

Designed by Sally Harris
and set in Monophoto Bembo type by
Asco Trade Typesetting Ltd., Hong Kong
Printed in the United States of America by
The Murray Printing Co., Westford, Mass.

Published in Great Britain, Europe, Africa, and
Asia (except Japan) by Yale University Press,
Ltd., London. Distributed in Australia and
New Zealand by Book & Film Services, Artarmon,
N.S.W., Australia; and in Japan by Harper & Row,
Publishers, Tokyo Office.

Library of Congress Cataloging in Publication Data

Kris, Ernst, 1900–1957.
 Legend, myth, and magic in the image of the artist.

 "Based on Die legende vom künstler . . . published in 1934
(Vienna: Krystall Verlag). The English translation was prepared
by Alastair Laing and revised by Lottie M. Newman. Additions
to the original text were made by Otto Kurz."
 Bibliography: p.
 Includes index.
 1. Artists—Psychology. I. Kurz, Otto, 1908–1975,
joint author. II. Title.
N71.K74 1979 701'.15 78-24024
ISBN 0-300-02205-0

To the Warburg Institute

Contents

Preface

This is an unusual book. The wealth of ideas and the range of documentation it contains would have led other scholars to write a large, heavily footnoted tome. Instead, Ernst Kris and Otto Kurz practiced the utmost economy of means without in the least curbing either the boldness of speculation or the variety of the evidence they wished to present. But then these two authors were at least as unusual as was their joint work. Ernst Kris, born in 1900, was in his early thirties, Otto Kurz, born in 1908, in his middle twenties, when they joined forces. Yet their chronological age obviously contrasted with their maturity as scholars. Both of them had been intellectual prodigies.

Ernst Kris had attended university while still a schoolboy. This irregularity arose from the shortage of coal during the miseries of the First World War and its aftermath in Vienna, when his school introduced a shift system and enabled the precocious pupil to spend the mornings listening to lectures on the history of art. Otto Kurz, during his last years of school, concentrated his extracurricular activities on the avid reading of the Latin writings of German Renaissance humanists, and in fact discovered an unrecorded but telling reference to Albrecht Dürer in one of these recondite texts. Both

of them became students at Vienna University of Julius von
Schlosser, a man of extraordinary erudition, whom Kurz,
in a moving tribute, was later to describe as a person born
out of his time. He was less like the head of a modern aca-
demic department than like one of the learned abbés of the
eighteenth century, happily browsing in old forgotten vol-
umes and talking of their authors as if he had met them in
the flesh. Schlosser's reputation now rests on his still un-
surpassed survey of the literature on art (1924) from the
Renaissance to the eighteenth century, comprising not only
lists of titles but also reflections on the biographies of artists
and on the guidebooks of the past. Kris, as a student, earned
the author's gratitude by compiling the index to the first
edition of that work. Kurz was later to keep the subsequent
Italian editions up to date.

Without this initiation, the book in the reader's hand could
not have been written. But what led Kris to embark on this
enterprise of research was connected with a different in-
tellectual adventure. He had joined the department of sculp-
ture and applied art of the Vienna Museum, which housed
and still houses the great Hapsburg collections, and had soon
turned himself into the leading specialist on Renaissance
engraved gems and intaglios on which he published the
standard work (1929) at the age of twenty-nine. But such
connoisseurship, which gave him an entry to all collections,
did not fully satisfy his inquiring mind, particularly since,
through his marriage, he had made contact with the personal
circle of Sigmund Freud. The first of his publications which
brilliantly combined both sides of his interests was an ex-
citing study, in 1932, on the Austrian baroque sculptor Franz
Xavier Messerschmidt who had earned a reputation in his
time with a large series of heads embodying a variety of

character types and facial expressions. The theme was popular in the eighteenth century, but it turned out that the version produced by Messerschmidt could not be explained as a purely intellectual exercise. A psychotic streak was apparent in these grimacing heads, and, following up this clue, Kris found indeed that the master had a record of severe mental illness.

It was through his research into the biography of this Austrian sculptor that Kris came across the problem of this book—the stereotyped anecdotes and legends so frequently told about the artists of the past. Thus Messerschmidt, like Giotto and countless others, was said in an early biography to have been a shepherd boy in his youth, an unlikely story, given his social background. Similarly, the realism of one of his crucifixes had given rise to the rumor—equally frequently encountered—that the artist had crucified his model to depict his agony.

It was natural for Ernst Kris, at this juncture of his life, to look for a collaborator to investigate with him such typical traits in the biographies of artists. He needed help, because he had meanwhile embarked on a dual career. Working his full eight hours in the Museum with incredible intensity, he had also turned psychoanalyst, seeing patients early in the morning and on his return from his job. It was fortunate indeed that he thus encountered Otto Kurz, who had, as it were, been digging his tunnel from the other side of the mountain. He had discovered that a story told by Vasari about the Florentine painter Filippo Lippi was in fact lifted from an Italian noveletta and transferred to the artist whose true romantic escapades may have invited such enrichment. Though he had but recently graduated, Kurz was already known among his fellow students for his near

omniscience and his epigrammatic wit. Utterly self-effacing but never obsequious, he combined the qualities of an ideal research assistant and of an uncorruptible critic.

To Ernst Kris, then, is due the profound intuition that the stories told about artists in all ages and climes reflect a universal human response to the mysterious magic of image-making; to Kurz, the ingenuity in tracking down parallels to illustrate and test the ubiquity of these motifs. Take a few paragraphs from the chapter entitled "The Artist as Magician" and admire the wealth of evidence as the argument moves with apparent ease from various Greek interpretations of the myth of Daedalus and his miraculously moving images to passages in Homer's *Illiad* and *Odyssey* and on to corresponding tales in Finnish and Lithuanian mythology, and after brief references to Pygmalion and Pandora settling down to select, out of various versions current in central and Eastern Asia, a Tocharish legend about the contest between a maker of automatons and a painter.

The reader need not feel embarrassed for never having heard of the existence of Tocharish legends. Only specialists in early Indo-European dialects of Central Asia have. And yet, such mere sampling gives a false impression of the book, which is not at all intended to overawe by a display of erudition. On the contrary. The authors aimed at a new style of scholarly exposition, fully documented but without the distractions of a learned apparatus and footnotes. The difference in type size should suffice to distinguish between the structure of the argument and the supporting material. Neither every surmise nor every known fact should find a place there. The reader will notice again and again that a trend of thought is merely indicated rather than spelled out. Exciting vistas open up, but we are not to linger and explore

them, for we must not lose sight of the main aim of the book—the establishment of links between the legend about the artist and certain invariant traits of the human psyche which psychoanalysis had begun to discern. Yet these central issues, as the authors stress in their joint Preface, were only to be hinted at occasionally and aphoristically. Kris did not want to commit Kurz, who was and remained basically a historian, beyond his chosen field. He rightly felt that he could and should expound these more technically psycho-analytic results under his own name and on his own re-sponsibility. He did so in a lecture given to the Psychoanalytic Society in Vienna in October 1934 and published a year later in *Imago*, the journal of which he had become an editor. (It forms the basis of chapter 2, "The Image of the Artist," of his *Psychoanalytic Explorations in Art*.)

If proof were needed that Ernst Kris had thus established an important connection between psychological theory and the creative imagination, it can be found in the address *Freud und die Zukunft*, which Thomas Mann delivered on the occasion of Sigmund Freud's eightieth birthday in 1936. The great novelist there paid tribute to this paper, which Kris had sent him and in which Mann found a sympathetic echo of the motif of role-playing which had deeply engaged him in his biblical epic *Joseph and His Brothers*. Turning to this book the reader will find the notions singled out by Thomas Mann in the concluding words of the last page— the notion of the influence the stereotype has on the artist's own life. It is all there, but as a sheer concentrate, encapsuled in a few lines of allusive prose. But is this not true of the whole book? It was only on rereading it after forty-four years that I discovered how much more there is here on every page than meets the eye.

I had joined the team when I was to assist Ernst Kris in another project which grew out of his interest in the magic power of art—a study of the history and function of caricature—while Otto Kurz was meanwhile to collect material on a major work relating to the prohibition of images in various religions and cultures. Naturally I was deeply moved to see how cordially the two had mentioned me at the end of their Preface to this book, though I really cannot remember having made any contribution to their ideas or research. What I do remember was the zest and pleasure which pervaded the atmosphere whenever I visited them after their joint sessions. There was much laughter and mutual banter as Kris would tell me about some out-of-the-way lore Kurz had got hold of, without wanting to incorporate it because enough was enough. Nor can I ever forget the deep concern which Kris showed for his younger collaborators which led him to find positions for us in the days overshadowed by the rise of Hitler.

Our mutual friendships outlasted exile. Ernst Kris, after a stay in England, settled in New York to become the respected authority on psychoanalytic theory and an admired teacher till his death in 1957. Kurz, on the recommendation of Kris, had joined the Warburg Institute, to which this book is dedicated, and after its emigration from Hamburg to London he remained there throughout his life as the indispensable librarian and scholarly oracle of that institution of learning. He died in 1975, having revised this book for a second edition by bringing the bibliography up to date and adding a number of footnotes.

April 1978 E. H. Gombrich

Foreword

We have subtitled this book "An Experiment," not in order to limit our responsibility but in order to characterize the intention of this study: we wish to record a series of questions without claiming to offer definitive answers.

External reasons, most of all considerations of length, have forced us to renounce any idea of completeness. From the wealth of material available, we have made a selection that appeared to us sufficient to document our arguments and justify our assumptions. Other reasons deriving from the material itself enjoined restraint: many of the relationships which we discovered in the course of our research have led to fields which are not accessible from where we start—the history of art.

The method adopted in this book is, as far as was possible, strictly historical. We have not thought it necessary to do more than refer summarily and in passing to the psychological interpretations suggested by historical connections. One of us (Kris), to whom the relationships examined in this book were in fact first suggested by the study of psychology, intends in a different place to go more deeply into

the psychological interpretation of the material presented here.[1]

With regard to the literature on the history of art, we have gratefully followed a school whose most distinguished exponents are Franz Wickhoff, Julius von Schlosser, Aby Warburg, and Erwin Panofsky.

We should like to take this opportunity to thank all those who have helped us with suggestions and advice. We feel particularly indebted to H. Gomperz, L. Planiscig, and K. Rathe (Vienna), F. Saxl (London), J. von Schlosser and H. Tietze (Vienna), and above all to our friend E. Gombrich (Vienna), who gave us his unwavering support.

Vienna, July 1934 Ernst Kris, Otto Kurz

1. Kris published the paper announced here in two versions: once in German as "Zur Psychologie älterer Biographik dargestellt an der des Künstlers," in *Imago*, 21:320–44, 1935; and in a revised form in English in his book *Psychoanalytic Explorations in Art* (1952, pp. 64–84) in the chapter entitled "The Image of the Artist: A Psychological Study of the Role of Tradition in Ancient Biographies."

1

Introduction

The *"Riddle of the*
Artist" as a
Sociological Problem The "riddle of the artist," the
mystery surrounding him, and
the magic emanating from him,
can be viewed from two per-
spectives. One can investigate the nature of the man capable
of creating works of art of the kind that we admire—that
is the psychological approach. Or one can ask how such a
man, whose works are readily accorded a particular value,
is himself evaluated by his contemporaries—the sociological
approach.

Both approaches presuppose that there is a riddle—that
certain special, and as yet ill-defined, traits and dispositions
are required for artistic creation, and that certain periods and
cultures have been prepared to accord a special, if ambiguous,
place to the creator of a work of art.

The two approaches naturally have many points of contact;
we are entitled to assume that on the one hand the reaction
of society to the artist is partially governed by his personal
characteristics and abilities, and on the other that this reaction
is not without its effect upon the artist himself.

Both approaches have reference to historical investigations.
Clearly, neither the various qualities and dispositions which

give rise to "talent" and the impulse to artistic creativity, nor the role that the artist plays in any given society, derives from a fixed set of conditions. Rather, they are subject to innumerable modifications, which can be understood only in the light of the historical situation.

This book deals with society's attitude to the artist, and therefore may be described as sociological; only where it touches on the question of society's concern with the riddle of the artist's personality does it border on psychology; but this boundary will not be overstepped.

The material that forms the subject of this inquiry has been selected according to historical criteria. It does not rely on a multitude of diverse details, facts, and assertions about the artist's life history. Rather, it is homogeneous in character. Our primary source is how the artist was judged by contemporaries and posterity—the biography of the artist in the true sense of the word. At the very core of this stands the legend about the artist.[1]

1. As the authors subsequently elaborate, these legends define "the image of the artist." In 1952, Kris added the following footnote to the English translation of his essay on "The Image of the Artist: A Psychological Study of the Role of Tradition in Ancient Biographies": "The concept of the 'image' has since the publication of this essay (1934) been used repeatedly in a similar sense. . . . There is a close relationship between the 'image of the artist' and what Linton (1943, pp. 129–130) has described as 'status personality.' He writes: '. . . in every society there are additional configurations of responses which are linked with certain socially delimited groups within the society. Thus, in practically all cases, different response configurations are characteristic for men and for women, for adolescents and for adults, and so on. In a stratified society similar differences may be observed between the responses characteristic of individuals from different social levels, as nobles, commoners, and slaves. These status-linked response configurations may be termed status personalities.' —Is not the artist a status personality of a special kind and does not the question of the comparative stability of his image pose a problem that deserves further attention by sociologists?" (p. 65f.).— *Editor's note.*

While we hope that this study will constitute the pre-liminary work for a future sociology of the artist, its scope must be further limited in two directions. First, we consider only the graphic artist—the painter, sculptor, and architect. Second, the accounts of their careers are presented from virtually one angle alone; we believe that we can demonstrate the recurrence of certain preconceptions about artists in all their biographies. These preconceptions have a common root and can be traced back to the beginnings of historiography. Despite all modifications and transformations they have retained some of their meaning right up to the most recent past; only their origin has been lost to sight and must be painstakingly recovered.

Historical Accounts Traditional records concerning *concerning the Artist* the life and career of an artist come into being only when it is the custom to link a work of art with the name of its creator. It is well known that this is not a universal custom. We encounter it neither among all peoples nor at all periods of time. It needs no special explanation that this custom is not found among the so-called primitive illiterate people who are supposed to have no "history," but we come to the heart of the problem when we are confronted by civilizations whose art we admire and whose history is familiar to us, yet we cannot name a single one of their artists. Whether or not an artist's name is recorded depends, not upon the greatness and perfection of his artistic achievement —even if this were objectively ascertainable—but upon the significance attached to the work of art. It would be beyond the scope of this study to attempt to determine how far this in turn helps to account for some of the characteristics of the work of art itself.

Very generally speaking, one can say that the urge to name the creator of a work of art indicates that the work of art no longer serves exclusively a religious, ritual, or, in a wide sense, magic function, that it no longer serves a single purpose, but that its valuation has at least to some extent become independent of such connections. In other words, the perception of art as art, as an independent area of creative achievement—a perception caricatured in the extreme as "art for art's sake"—declares itself in the articulation of the growing wish to attach the name of a master to his work. There are two occasions in the known cultural history of mankind when this attitude has been given full expression: once in Western civilization, in the Mediterranean basin, and again in the Far East. Our thesis is that from the moment when the artist made his appearance in historical records, certain stereotyped notions were linked with his work and his person—preconceptions that have never entirely lost their significance and that still influence our view of what an artist is.

This assertion is more likely to meet with assent in the case of those records that we have from the Far East than in those from Europe. For we have been taught to attribute such a special role to the forces of oriental tradition, that we are alert to the dangers of arriving at false conclusions by employing ideas of historical development derived from Western experience; whereas in Europe the assumption that there exist certain uniform images of the artist seems to run counter to the generally accepted picture of the course of Western civilization. So before attempting to present the material from which we have arrived at our conclusion, it is incumbent on us to demonstrate, in broad outline at least, the uniformity of accounts relating to artists in the West.

Their origins invariably are Greek. It is exceptional for an artist to be named in the surviving records of the ancient Orient and Dynastic Egypt, and even then his name is not linked to any work. Only the Old Testament occasionally mentions artists and their works.

What we know of pre-Hellenic traditions in the Aegean has been transmitted to us by the Greeks themselves, and must be unraveled from their mythology. Even in classical Greece the special role of the artist became established rather late, and then only against considerable opposition. The signatures of Greek artists from the sixth century B.C. are the first heralds of future artistic renown; and the scattered references to artists in the literature of the archaic and classical eras are the precursors of artists' biographies, which emerged as a distinct literary category in the Hellenistic period. These were the first of their kind.

Their importance was soon so great that the enduring fame of several Greek artists—Zeuxis and Apelles, to name but two—rests on these biographies alone, without there having been any possibility of later forming an impression of their actual works. That the fame of an artist can thus outlive any of his productions is in itself a striking affirmation of the potent influence of the Greek biography of the artist. The knowledge of such biographies has never been entirely lost since antiquity, having been kept alive at least in Byzantium throughout the Middle Ages.

The image of the artist documented in the Greek biography of the artist must be regarded as an acquisition of Greek culture; even Roman connoisseurs—save for a few exceptions in the Republican era—knew only the names of Greek artists.

The anonymity of Roman artists extended beyond the

Empire and persisted among those peoples who attempted to enter the European cultural community. The rare instances of an artist's fame in the early Middle Ages always hark back to antiquity; wherever in the Romanesque and Gothic periods a breach in the tradition of artistic anonymity occurs—beginning, as before, with the appearance of artists' signatures—the formal characteristics of the work of art are borrowed from classical sources. Finally, in the late Middle Ages, in the fourteenth and fifteenth centuries, when the figure of the artist emerges on the historical scene and gains independent stature in every way, biography of the artist as an independent entity emerges as well. This happened first on classical soil, but soon spread north of the Alps; nonetheless, in every case, as the documentation that we have amassed amply demonstrates, it is always directly inspired by those same original accounts of the Greek artists.

From this time on an unbroken sequence of literary accounts referring to artists extends right up to the present. The sociological view they offer is most diverse: from the world of the guild and the masons' lodge they take us to the studios of the Renaissance masters who were inspired by humanism; from the patronage of the Church and of merchants to that of princes; from the constraints of being a craftsman to those of the academic tradition; but they also show the ultimate attainment of individual self-expression and the highest esteem of creativity in the *divino artista*. In each phase of this historical development new social types appear alongside the old, without ever entirely displacing them. The revolutionary innovator stands next to the head of an academic school, and the artist as a universal genius or gentleman stands side by side with the unrecognized and

solitary figures. This diversity of social background appears among the artists of the nineteenth century whose world embraced the fêted darling of his prince and country just as much as the slouch-hatted Bohemian living out his conception of genius on the social periphery, in Schwabing, Montmartre, or Greenwich Village—a vanishing world which, where it still survives, belongs to yesteryear. In this world, however, the artist does not stand alone: he is a member of the great "community of geniuses."

The attempt to seek a common denominator in such diversity may appear to be a perilous task. That it can be done becomes clear only after one recognizes that a transformation in the view of artists has taken place. This change enabled us to gain "distance" from the object of our inquiry. It is claimed that the present-day artist is bent on breaking with old traditions, and that he seeks a new place in society, a defined place in the community. At the same time one can discern a change in the attitude of society, which can be appreciated in the turn that art-historical studies have taken. Dispensing with biographical curiosity, their banner reads: "Art history without artists." An astute contemporary scholar, Benedetto Croce, aptly described this new way of looking at things in the observation that what matters is the aesthetic, and not the empirical, personality of the artist— the creator of works of art, and not the man living in the everyday world. Even if this seems to sever, rather than unravel, the Gordian knot tangling the artist with his work, this conception should be considered in our context: it speaks for the intention to see the position of the artist in a new light; but perhaps it also implies that the master is ready to give precedence to his work.

Anecdotes about Artists, and In the numerous accounts of the
Some Biographical Motifs lives of painters and sculptors
 that have come down to us from
the Renaissance onward one repeatedly encounters typical
leitmotifs—themes that recur in numerous biographies with
little or no variation. These relate either to the career of the
artist—particularly to his childhood—or to the effect of his
works upon his public.

Several biographies tell of how the master first gave evidence
of his gifts by sketching the animals he herded as a shepherd.
Then a connoisseur happened to pass by, recognized the extra-
ordinary talent in these first artistic endeavors, and watched over
the proper training of this young shepherd, who later emerged
as this or that far-famed genius. This account has a number of
variants, in some of which all the episodes are retained, or several
are merely modified, whereas in others only the central theme
is retained—that the artist's gifts were already evident in his
childhood.

Another narrative formula is designed to leave no doubt as
to the artist's capabilities: the master painted a bit of nature so
skillfully that observers mistook it for the real thing, for example,
a spider poised to scuttle across the picture. His accomplishments
were especially noteworthy when he succeeded in deceiving his
fellow artists. There are simply untold numbers of the same or
similar stories. Whatever else may be modified, the setting, the
atmosphere of the artist's studio, rarely varies, but the core of the
episode never does: that the artist's work is taken for nature's own.

We have singled out these two basic examples, which will
also serve as a starting point in subsequent sections, in order
to raise the initial question: what can we conclude from
such consistent accounts? In the case of the first, the tale of
the artist's youth, one might be inclined to say that the ac-

count emphasizes a typical element in the development of an artist; that the vocation of shepherd or cowherd is said to be particularly apt to stimulate latent artistic talent; and that, generally speaking, it is of the greatest significance that the artist's talent already is evident in childhood. One could even take these traditional accounts concerning the life of great artists as the basis for psychological speculation. We could then try to understand the second group of stories analogously: great artists are apparently capable of deceptively imitating nature. In this case it is hardly surprising that their biographers should stress precisely these abilities.

Such explanations—which may be termed rationalistic—can barely be maintained with regard to the first group of stories, especially if one considers the remarkable number of exactly identical accounts; in the case of the second group, they are untenable. For in answer to the question, "How far does the ability to imitate nature extend?" we can be perfectly confident of our reply, "Not that far." We would neither take a portrait of the Emperor Charles V painted by Titian for the Emperor himself (as it is related that his son Philip II did), nor would we take for a real insect a spider such as the one that Dürer is reputed to have painted on a picture by Michelangelo (Hampe, 1928). It was long ago realized that different explanations must be found. In this endeavor the tools of textual criticism proved to be successful. This method showed that the shared elements in stories relating to quite different people were explicable in terms of their common derivation from the same source. The tale of the artist as shepherd boy stemmed from a popular story about Giotto's youth, an oral tradition that began to take shape in Florence about a century after the master's death; the other went right back to classical antiquity, being

modeled on the famous competition between the two Greek painters, Zeuxis and Parrhasios, as recorded in the *Encyclopedia* of Pliny the Younger. Eventually, it became the custom to label these stereotyped episodes, and others like them; they became known as "artist anecdotes."

In order to circumscribe the meaning of this label, it is necessary to say something about the nature of these anecdotes, insofar as this has a bearing on our further considerations.

At present we are inclined to associate the anecdote with jokes. The difference between the two, though real, is slight and not easy to define, but their structure is the same. An anecdote, like a joke, has a "point" that is tied to the pleasure gain. (This aspect will not be elaborated here because in this context we are interested in the content of the anecdote.) As a rule the anecdote deals with a prominent person or a hero—or it substitutes a particular social type—who is brought closer to our understanding, so that we can identify with him more easily. Hence what is related about the hero is mostly to be regarded as a gloss upon his "official" biography, and presents the great man as one with human foibles, or else shows his adroitness in a new and unexpected light. One could call the anecdote an episode from the secret life of the hero. Here we seem to touch upon the oldest meaning of the word, which, deriving from the Greek ἀνέκδοτον, is still used in its antiquated sense to designate something new, unknown, and therefore secret (Dalitzsch, 1922). Here the anecdote borders on the field of the short story, as the Italian *novella* was originally understood, and with which it was so closely associated at the beginning of the nineteenth century that the critic C. F. von Rumohr (1835, 2:38) was inclined to regard the two as synonymous—a usage that has persisted.

Anecdotes have indeed been repeatedly used as sources in the writing of history. The fact that they occasionally convey something significant about their hero, and very often provide a deeper insight into his personality than other

sources, evidently induced Nietzsche to assert that one could sum up the character of any historical person with the aid of three anecdotes. One might similarly utilize anecdotes about artists as a source for their biographies and, by collecting stories about this or that leading artist, expect to illuminate his life and gain insights into his character not supplied elsewhere. While the questions posed in this study could be regarded as laying the groundwork for such investigations, their use and value might still be debatable depending on one's point of view. For we intend to deal here precisely with those anecdotes that do not relate to one specific artist; their truth would need to be rigorously checked if one seriously wanted to use them in the biography of an individual artist.

What we have done is to extract these anecdotes from the descriptions of the lives of various artists. We regard the hero of these typical anecdotes as depicting the typical artist —as *the image of the artist* which the historian had in mind. The question whether statements contained in an anecdote in this or that particular case are true then becomes irrelevant. The only significant factor is that an anecdote recurs, that it is recounted so frequently as to warrant the conclusion that it represents a typical image of the artist. This approach compels us to expand the existing concept of the "artist anecdote." Speaking in the most general terms, we can say that we seek to understand *the meaning of fixed biographical themes.* In this sense the anecdote can be viewed as the "primitive cell" of biography. While this is obviously valid of biography in general, it is particularly true and historically proven in the case of the biography of artists.

One of the first texts in the literature of art of which we have some knowledge—it was written in the late fourth century B.C.

by Duris, the Tyrant of Samos and a knowledgeable adherent of the Peripatetic school—already contains the germs of the most important anecdotes that we shall discuss. In Duris's work, which textual research reconstructed with rare circumspection, the anecdote is used throughout as a literary device.

At the same time, however, the anecdote is intimately linked with the legendary past, in which the image of the artist originated. For historians have learned to recognize that the anecdote in its wider sense taps the realms of myth and saga, from which it carries a wealth of imaginative material into recorded history.

Thus, even in the histories of comparatively modern artists we find biographical themes that can be traced back, point by point, to the god- and hero-filled world before the dawn of history. These themes can be demonstrated to occur again and again even outside of the orbit that links our Western tradition with ancient Greece; this is, in fact, the significance of the oriental, and especially the Far Eastern, parallels to which we shall frequently refer.

In summary, our inquiry is directed to those typical themes in the biography of artists which, in their totality, we call "the legend about the artist." We want to trace them back—at least in broad outline—to the threshold of written history, to the ideas that appear generally to be associated with the fact of artistic creativity in man, restricting our study to painters, sculptors, and architects. We shall then present several examples to illustrate that these ideas lived on until the time when the graphic artist became a member of the "community of geniuses" and when his environment began to regard him as it did other creative personalities.

2

The Heroization
of the Artist in
Biography

The Artist's Youth The universal interest in every-
thing reported about the child-
hood and youth of exceptional persons has deep roots in the
human mind. This interest is usually accounted for in two
ways. One point of view states that childhood events have
a decisive impact on the future development of man; hence
the attempts to demonstrate the early influence of fate in the
lives of the great men of history. The other interprets the
earliest available information about the lives of the heroes
not as precursors in terms of causality, but as premonitory
signs; it sees in the experiences of the child an indication of
his future accomplishments and regards them as evidence
of the early completion of uniqueness. This view is more
comprehensive and probably also the original one.

The first of these two views has received unanticipated corrob-
oration from the findings of modern psychology—that is, from
the psychology of Sigmund Freud, who recognized that an

individual's life history is the route to the understanding of his personality. Freud attached the greatest importance to the very earliest impressions because the subsequent development of the personality can in many ways be traced to the very first experiences.

But the second view has also persisted, though in a somewhat restricted form. It is implicit in the hypotheses of the research into heredity and constitution that aims at defining the limits of the applicability of the developmental psychology described above.

The two points of view—and their delimitation and interpenetration in the autobiographies of the last few centuries would be a rewarding task for historians of psychology—are by no means mutually exclusive. Both appear to stem from society's urge to find some access to the exceptional or gifted figure. For this reason virtually everything that is reported about the childhood and youth of anyone who has a claim to a biography bears some relation to the sphere in which he subsequently distinguished himself—in the case of the artist, to his choice of profession and to the first demonstration of his abilities.

Before attempting to define the nature and bias of these traditions, we shall let the sources speak for themselves.

An early account of the youth of Lysippus, the great sculptor of Alexander's time, is a good introduction to the ideas of the classical biography of artists, though it has had to be reconstructed from fragments. The account is taken from the great encyclopedia of antiquity, the *Historia Naturalis* (34:61) of Pliny the Elder.

It is reported that Lysippus had no teacher. Starting out as a coppersmith, he decided to become an artist only when he heard his countryman, the Sicyonian painter Eupompos, answer a

question (from a third man?) as to which of his predecessors he followed. Pointing to a motley assortment of people, Eupompus said, "All of these"—that is to say: Nature, and not the manner of some other artist, is alone worthy of imitation. (*Naturam ipsam imitandam esse, non artificem.*)

This anecdote, as Pliny himself indicates, derives from *Lives of the Greek Sculptors* by Duris of Samos, a work which is known to us only from scattered samples of meager quotations. Thus it is almost contemporaneous with Lysippus himself. Its anecdotal form as well as other devices are characteristic of the writings of this prolific author and earned him even in antiquity the reputation of being unreliable (see Plutarch's *Pericles*, 28). Yet Duris's subtlety in weaving a variety of themes into an apparently simple story becomes apparent when we dissect the anecdote and list its individual elements. It contains four statements:

1. Lysippus turned himself from a coppersmith into a great artist.

2. He had no teacher.

3. He happened to overhear a remark made by Eupompus and this accidental circumstance was decisive for his choice of profession.

4. This remark was to the effect that Nature, and not some old master, was alone worthy of imitation.

We shall address the fourth statement first. It belongs in the aesthetic sphere—the style of an artist who acknowledges Nature alone as his model—and is in full agreement with the picture of Lysippus as an artist, as it was current in antiquity and as it has since been established by modern research.

Since Alexander's time Lysippus has ranked as one of those to whom "the conquest of Nature through Art"—the ideal that also

emerges from Pliny's account of him—owes most. In classical antiquity he was already credited with saying that the ancients (his predecessors) had depicted men as they were, whereas he depicted them as they appeared (Pliny, 34:65). This tallies with Plutarch's assertion that Alexander the Great wanted to be portrayed only by Lysippus, such were the master's powers of accurately observing his model (Overbeck, no. 1480). We may also, at least in part, regard a report about Lysippus's brother as a further characterization of Lysippus himself. His brother Lysistratus is supposed to have hit upon the idea of taking casts from live forms, a mechanical procedure that enabled Lysistratus to be "the first" to achieve exact likenesses. Thereby he followed Eupompos's advice literally, but by overstepping a boundary he left the artistic character of his work open to doubt: Nature was not the model of the artistic form, but was borrowed from directly.

While the maxim *naturam imitandam esse* serves to define the nature of Lysippus's artistic bent and achievement, further details about his accomplishments are reported: they were new and revolutionary; Nature replaces the legacy of earlier artists as the model.

Eupompos's remark joins the repudiation of tradition with the adherence to nature. It is undoubtedly due to this double meaning that he is referred to again and again to characterize new programs of realism in art. It comes as no surprise that Aretino, for example, cites Eupompos to define the originality and vitality of his own style (Zilsel, 1926, 238), nor to find that the learned antiquarian Bellori (1672, 203) put Eupompos's words into the mouth of Caravaggio, the extreme exponent of a highly controversial form of realism. It is remarkable, however, to encounter them in the *vita* of Guido Reni as well, though in this instance it is used to designate classicistic tendencies (Passeri, 1772, 59). For when Reni was asked by his pupils where he found models

with features as fine as those in his pictures, he pointed to a collection of plaster casts of antique statues. Thus the form of the anecdote has been severed from its connection with a specific content and survives independently. Moreover, it is also to be found in China: the famous horse painter Han Kan is reputed to have said that the horses from the Imperial stables, not painters, had been his teachers (Giles, 1905, 58).

Returning to our original illustration, we wish to emphasize that the statement attributed to Eupompos, insofar as it relates to the repudiation of ancient masters as models, is linked by Pliny with another biographical fact in the life of Lysippus—with the tersely recorded information that Lysippus had no teacher. This report stands in need of its own explanation. Even though only few documents have been preserved, we know of a number of artists of antiquity of whom it is reported, in almost exactly the same words, that they grew up without a teacher; it is said of Silanion and Erigonos (Pliny, 34:51, 35:145) and of Pasiteles (see Pausanius, 5:20.2 in Overbeck, no. 845). This special emphasis on autodidactism in such scant reports on the lives of artists also has been traced back to Duris, who used it as a formula (Sellers, 1896, xlviii, 231). The analysis of texts further suggests that these reports of autodidactism are linked with others relating to an abrupt rise in the artist's social standing. In the case of Lysippus, this was, as we saw, from coppersmith to celebrated sculptor (and, one might add, from craftsman to an artist renowned for his legendary wealth); and in the case of Erigonos, from color grinder to painter. Nor is this the only place in Duris's writings where he seems to have stressed this theme; he relates, for instance, of so celebrated a hero as Eumenes of Cardia that he was born the son of a coachman, and came to Philip of Macedon's

notice only by chance—"though others give a different
account" (Kalkmann, 1898, 144; see also Münzer, 1895,
534). An attempt has even been made to account for Duris's
predeliction as deriving from the personal experiences of a
man who was born in exile, but who was destined to receive
the crown of Samos. This can at best be only an ancillary
explanation, for this dramatization of someone's life, even
though it may on occasion accord with the actual life experi-
ences of the historian or his hero, is a basic attitude of Duris's,
reflecting his adherence to the Peripatetic school. Such
incidents illustrate the influence of the forces of fate, to
which all mortal life is subject, and dramatize the power
of Tyche, the author of all sudden change in circumstances
—a view of life which derived from the works of the rhetor-
icians and tragedians and found their way into the writings
of later historians (Rösiger, 1880). It displaced an earlier,
mythological view of life, according to which the twists
of fate were directly attributable to the will of the gods.

The manner in which the episode of Lysippus's youth is
recounted makes the connection with the Peripatetic con-
ception of Tyche particularly evident. It is chance that brings
the coppersmith together with Eupompos, who then states
a proposition crucial to Lysippus's choice of profession and
the brilliant career it opened for him. (Pliny's text can also
be taken to mean that there was no direct contact between
Eupompos and the coppersmith Lysippus, but that the latter
only heard of his utterance by chance.)

Having demonstrated that references to the artist's rise
in social standing recur as a typical biographical motif,
especially in connection with contemporary views of the
power of fate, we can now attempt a similar explanation for
the other recurrent motif that we unearthed in Duris's bio-

graphies—the repeated emphasis on autodidactism. It must be obvious from the accounts already quoted that the artist who was said to have been self-taught also won fame as an inspiring teacher.

Silanion, for instance, "who was admirable for winning renown without a teacher [*nullo doctore*]," was nonetheless himself the teacher of the famed Zeuxis; a similar story is told of the color grinder Erigonos who had the even more famous Pasias as a pupil (Pliny, 34:51; 35:145).

The reason for this becomes apparent when we reflect upon the fact that the form in which the history of Greek artists has come down to us was laid down by διαδοχαί, that is to say, by lists of pupils set out according to lines of succession. This type of arrangement seems to have been modeled on one reported to have been used for the various philosophical schools. We are familiar with the importance which a classification according to schools had for all areas of cultural activity in classical Greece, and we are in a position to demonstrate the influence of this in the anecdote about Lysippus's choice of career. For the very achievement for which Lysippus was singled out for renown—the introduction of realism in art—is not credited to him, but is attributed to the traditions of his native city Sicyon; the credit for this achievement is given to the otherwise virtually unheard-of older painter Eupompos, who is cited as the author of the doctrine of naturalism. There can be no doubt whatsoever that Duris's account was not dictated by known facts; rather, we are dealing here with an anecdote whose shape was determined by the conscious intentions of its author. Textual research has even gone so far as to doubt, on the basis of dating, whether a meeting between Lysippus

and Eupompos was even possible. (For a contrary view, see B. Sauer's entry on Eupompos in Thieme-Becker, 1907, 11:85.) Indeed, if we grasp the point of the story, the encounter need not have taken place at all. For the purpose of such a meeting, in which the young smith is shown the path to follow by the older Sicyonian painter, is to provide an ideal teacher for the genius of Lysippus, who grew up "without a teacher." It must, however, have seemed particularly apt to attribute the maxim of naturalism to Eupompos, since his very name—and one can readily expect this kind of word-play from the etymologically oriented mind of Duris—meant "trusty guide" (Münzer, 1899, 983).

The tale of Lysippus's choice of career thus contains two elaborations of the problem of the artist's independence of or dependence upon school traditions. If we keep in mind that considerable attention is paid to this problem in the scant remains of Duris's writings, we become aware of a polarity that played an important role in Greek culture as a whole. Originating in mythology, it permeated the writing of history. The autodidact represents one side of this polarity, reflected in the elevation of the creative individual to the status of a culture hero. The other side reflects the urge to anchor the individual's achievement firmly in the dynastic succession, a process we might refer to as "genealogization."

There are two possible ways by which the image of the culture hero may have come about. Either the memory of an actual artist was heroized in retrospect, or some divine personage was vested with a particular achievement. Little would be gained by a detailed examination of how the two roles became merged and the motifs interwoven, for essentially the same process was involved in both cases—the elevation of human endeavors to divine rank. At one end stood the concept of *deus artifex*, the

Creator as divine artist (which will concern us later), and at the other end stood artists whose historic existence had passed into myth, e.g., Imhotep, the famous architect of the Third Dynasty Pharaoh, Djoser, who in the last Dynastic period was revered as a demigod and son of Ptah (Roeder's entry in Pauly, vol. 9, col. 1213 [see also Junker, 1960, 76–79]); or Daedalus, who was viewed as "a sole echo of the great artists of the second millenium B.C." (Schweitzer, 1925).

The image of the culture hero became particularly important for historical literature, especially in the case of the graphic arts. The origin of every artistic technique had to have an "inventor." Thus Imhotep was credited (by Manetho) with the invention of building in ashlar. In Egypt, the invention of painting was traditionally ascribed to the Lydian, Gyges (Pliny, 7:205); in Greece, to Eucheir, a relation of Daedalus (Pliny [7:205], citing Aristotle); and in China, to Shi Huang, a contemporary (or, according to other accounts, another name) of Ts'ang Chieh, the legendary inventor of writing (Hirth, 1900).

In classical antiquity the image of the culture hero assumed a central position in historical thinking; an independent literary category is devoted to the εὑρετας—the inventors of every branch of human activity—of which traces survive in Pliny's great *Encyclopedia*. Thus Dipoinos and Skyllis were held to be the inventors of marble sculpture, and Butades the discoverer of ceramics, to name but a few more examples (Pliny, 36:9; 35:151).

The fact that the categorization adopted even in some of the most modern art histories is codetermined by this source demonstrates the indissoluble connection between modern and mythopoeic thought. "And thus it develops that there is no hiatus, no sharp *temporal* dividing line, . . . between the theoretical and the mythical consciousness. Science long preserves a primordial mythical heritage, to which it merely gives another form" (Cassirer, 1925, xvii).

The fragments of the earliest Greek biographies of artists

that can be reconstructed from subsequent borrowings all stem from a period in which the figure of the artist had only just emerged from the realm of myth; they preserve the conception and many elements of myths, and transmit them to posterity. Their traces can readily be detected in the anecdote about Lysippus's choice of profession. They govern the schema of presentation of all writing about art in antiquity, whether biographical or doxographical—that is, art history as opposed to the histories of artists. Pliny drew on both the biographical and the doxographical traditions of Greece. He conferred a dual role on artists, attempting both to honor the innovator for inventing a particular technique or making a particular advance, and yet to set out as detailed pupil-teacher genealogies as possible. Pliny's method formed one of the bridges across which this basic conception was transmitted to subsequent historical writings.

We encounter this constellation at the very beginning of the biography of artists in modern times—in the famous story of Giotto's youth. Thanks to the fine researches of Franz Wickhoff (1889) and Julius von Schlosser (1896), we may view this story as the precursor of a favorite theme in the later literature on art.

The formulation of this anecdote was prompted by a passage in the eleventh canto of Dante's Purgatorio, in which the poet mentions two of the leading artists of his age and sets one off against the other:

> Credette Cimabue nella pittura
> Tener lo campo, ed ora ha Giotto il grido
> Sí che la fama colui oscura
>
> Once, Cimabue thought to hold the field

> In painting; Giotto's all the rage today;
> The other's fame lies in the dust concealed.
>
> (Dorothy Sayers)

The commentaries on the *Divina Commedia*, which played such an important part in the intellectual life of fourteenth- and fifteenth-century Florence—even Boccacio contributed, with a commentary on the first sixteen cantos of the Inferno —soon attempted to throw more light on this passage. The intention, it was said, was to fill out the contours of the earlier of the two painters, whose image had become shadowy with neglect, and to make clear his relation to Giotto. But thereby the point of Dante's juxtaposition was lost, and a new sense was substituted for the old. For Dante, the point of this, as of other similar juxtapositions, was to set down an *exemplum morale*. "O vana gloria dell'umane posse" ("O vain glory of human endeavor") is his theme here, summed up once more in the verses that almost immediately follow the passage already quoted:

> Non è il mondan romore altro ch'un fiato
> Di vento, ch'or vien quinci ed or vien quindi,
> E muta nome perchè muta lato.

> A breath of wind—no more—is earthly fame,
> And now this way it blows, and that way now,
> And as it changes quarter, changes name.
>
> (Dorothy Sayers)

The Dante commentators—whose view was followed unquestioned until Karl Vossler (1909) recognized the character of the *Commedia* as "moralizing exemplifications" —interpreted these lines as referring to a historically intended contrast between generations, and attempted to establish a

connection between the representatives of an earlier and a
more modern group of artists. To do this they drew on
material which evidently originated in the oral traditions of
Florence—a town that has retained its creative vitality to
this day. Cimabue was made the greatest artist of his day,
the Ducento, and then, in a report which goes back no
further than the early fifteenth century, the teacher of
Giotto. Not only does this piece of information have no
basis in any tradition traceable to the lifetime of either of the
two men, but it is also contradicted by everything that we
do know with any certainty of their lives, and particularly
of their works—even though only a pale reflection of
Cimabue's opus survives to judge him by. The story has
long been recognized for what it is—history faking. Here as
elsewhere, the popular imagination has tried to link glam-
orous figures from the past with one another. Such a process
of linking, which leads directly to the formation of sagas and
legends, makes Cimabue into Giotto's teacher. It springs
from the urge to provide a genealogy for the achievement
of the great man who revived Italian art.

The mere circumstance that Cimabue was thus made into
Giotto's teacher would not in itself be sufficient to connect
the anecdote deriving from the Tuscan tradition with the
example of Lysippus from antiquity. The specific circum-
stances in which this report is cloaked, however, leave no
doubt about this derivation. The account comes down to
us in two versions. According to the first, which stems from
the so-called Anonimo's commentary on Dante (Wickhoff,
1889), Cimabue as an old man took on Giotto who had been
apprenticed to a wool dealer and had run away from the
workshop in order to paint. The other version is first found
in the great Florentine sculptor Ghiberti's *Commentarii*, one

of our earliest and most reliable sources for the knowledge of Italian art, dating from the mid-fifteenth century. The most celebrated version of this story was Vasari's highly adorned account (1 : 370):[1]

Giotto, the son of a simple peasant, tended his father's flock and drew pictures of the animals on stones and in the sand. Cimabue, who happened to come by, recognized the shepherd's great talent, took him along, and saw to the training of the boy destined to become one of Italy's greatest artists.

Before attempting to pursue the migrations of this anecdote, we must break it down into its constituent elements.

1. Cimabue became Giotto's teacher.

2. A chance encounter led to their association.

3. This accidental event paved the way for Giotto, the shepherd boy, to rise on the social ladder.

4. Even in his childhood Giotto's miraculous talent, revealed in his drawings of animals, drove toward artistic expression.

The themes disclosed here have many points of contact with those revealed by our analysis of the story of Lysippus's choice of career. Alongside the general tendency to genealogize that is expressed in the linking of Giotto and Cimabue, as pupil and teacher, there are more specific similarities that relate to the workings of fate—the role of Tyche. In both cases the effect is twofold; on the one hand, Giotto too is permitted to rise high from humble beginnings; and on the other, the decisive change in his life is due to a chance

1. See also Ghiberti (1:35). "Cimabue finding the shepherd boy Giotto" became a popular subject of painters in the nineteenth century, particularly in France, but also in England (Sir Frederick Leighton), Italy, and Germany (P. Cornelius). See Haskell (1971, 67), Förster (1875, 22), and Barocchi (1974, 105).

event—the discovery of his talent by Cimabue who "happened" to pass by.

The immediate model of this presentation actually was not the account of Lysippus's choice of career, but other ancient stories involving fortunate chance meetings and discoveries. Similarly, Herodotus is supposed to have discovered Thucydides' ability, and Xenophon to have encountered Socrates (and passing mention has already been made of another such story, on page 18).

It would appear that at this point the similarities between the two stories that we have been discussing are exhausted. For in the anecdote about Giotto's youth, neither the chance encounter with Cimabue nor his being a pupil of the latter, nor the rise in his social standing, occupies the foreground of the story. It is far more critical that the artist's talent already strove for expression in childhood, revealed itself early, and attracted the attention of others. It is this motif that again and again constitutes the central point in the innumerable variations of the theme. The fact that we do not encounter this theme in the ancient accounts relating to artists seems to be intimately connected with the social standing of artists in antiquity.

The Discovery of Talent The story of Giotto's youth
as a Mythological Motif fathered numerous others of the
same kind, in which the theme
that we propose to designate as the "tale of the discovery of talent" figures prominently. The evidence before us requires an evaluation of sources to lay the foundation for all further discussion.

According to Vasari (5:142), relying apparently upon Sienese oral tradition, Beccafumi was led to take up his profession in

just the same way as Giotto. Born the son of a peasant called Meccarino, he tended his father's sheep and made drawings of them in the sand; he was then discovered by a Sienese nobleman, who saw to his training, treated him as his own son, and finally made him the heir to his noble name. Vasari (4:510; 2:668) gives identical accounts of the early years and discovery of both Andrea Sansovino and Andrea del Castagno (Frey, 1892, 20). This tale of the discovery of a gifted shepherd boy found sketching was later adopted for both Zurbarán and Goya, though there exist two more alternative versions of the legendary discovery of the latter (Kehrer, 1918, 20; n.d., 5; Loga, 1903, 4). But in Vasari's biography of Castagno yet another motif makes its appearance: the shepherd boy found (just like the others) by an aristocratic patron (in his case, the Florentine nobleman Bernadotto dei Medici) had previously watched a local painter at work and been stimulated by that. The biographical formula itself caught on fast, though one feature or another might be omitted. Thus, for instance, Bernardo Pocetti was discovered by Ridolfo Ghirlandaio as a tiny six-year-old drawing figures on a church wall (Baldinucci, 3:134). Or, to cite a remote derivative, the Japanese painter Maruyama Okyo was discovered by a passing samurai, having painted a pine tree on a paper sack in the village store (Kümmel in Thieme-Becker, 6:586). The other feature, that of the early encounter with other artists, which similarly gives the element of chance its full due, also was widespread. We encounter it in the story of Polidoro da Caravaggio's youth; according to Vasari (5:142), he was carrying buckets of plaster to the masons working on the Vatican loggias; when the painters also employed there were absent, he tried his hand at painting the frescoes himself. A similar tale is told about the artistic beginnings of the Cavaliere d'Arpino (Sobotka in Thieme-Becker, 6:309); but the note of artistic rivalry sounded in these accounts stems from a different source, which we are not yet ready to pursue. The same theme occurs, though with some of the details

altered, in the lives of Pierino del Vaga, who as a storekeeper's apprentice brought painters their colors (Piles, 1715, 201), and of Guercino, a farmer's son who took a cartload of wood to Bologna, and went to the atelier of the Caracci, where he had the opportunity of leaving a sample of his talent, after which he began to sketch his impressions of the surrounding countryside (Passeri, 1772, 369).

Let us focus on the factors that these episodes in the youth of artists have in common. They can be seen to take up two of the motifs found in the fable of Giotto's childhood. One is the influence of chance that enables the youth to choose his career and thence to rise in social standing; the other is the discovery of talent. The classical roots of both themes were demonstrated in various places, but the second motif permitted us to point to a new biographical formula. It singles out the early accomplishments of talent and seeks to highlight that a master's genius already strives for expression in childhood. This turns out to be the most common theme in the biographical "childhood histories" of artists, a few of which we shall mention briefly.

In all the accounts of Filippo Lippi's childhood, it is said that from early on the boy, who grew up in a monastery and was intended for the religious life, "spent the whole day covering paper and walls" (Bandello, nov. 58; Vasari, 2:612). This version of the tale is encountered with astonishing regularity. Thus, like Lippi, Netscher and Poussin are said to have filled their schoolbooks with scribbles instead of lessons.

At this point we must insert a remark. There is general agreement that this particular biographical detail has a high claim to probability. Its prototype seems to stem from that of life itself: an artist's talent strives early and urgently for expression.

We can do no more than touch on the possible objections to this view. Certain facts speak against the assumption that a painter's or sculptor's talent can regularly be recognized early and unequivocally; for example, many great artists chose their career late in life. But it must also be emphasized that the problem we are discussing defies solution. Subjecting the material of old biographies to statistical analysis would beg the question since it is precisely their reliability which is at stake, so that in the final analysis one could consider as clear evidence only those works of art that are known to have been executed by the great artists in their youth. Even the findings of modern child psychology do not provide a conclusive answer, nor do they permit us to draw conclusions about the past. We may assume that the age at which a child's ability first becomes apparent—in terms of numerical average, which is all that can be taken into consideration here—has not been the same at every point in history. The focus of our observations obviously has shifted somewhat since we have learned to take an interest in the drawings of children. Judging on this basis, however, one would be struck by how few of the "gifted" children succeeded in maintaining their abilities beyond the "latency period"—a fact for which there are good psychological reasons that we need not go into here. We are therefore entitled to take the view that out of a plethora of gifted children only a few subsequently emerge as artists. The fact that we have such information about this particular handful is primarily due to their having been singled out as the heroes of the biographies of artists.

We accept the assumption, then, that great artists do indeed frequently show their talents in childhood, and that this biographical formula is rooted in everyday experience. This affords us the opportunity of reaffirming the nature and limits of our own inquiry. We repeat that we are concerned here not with what happened in the life of this or that particular

artist, but only with the nature of the information that is identifiable as a typical part of the common fund of tradition.

If we let ourselves be guided by our source material, however, we can fully corroborate our view that the accounts concerning the early manifestations of talent among great artists do indeed constitute a biographical formula.

The tale of the early stirring of artistic talent is indiscriminately used as biographical padding. Thus, to cite a particularly clear example, it was trundled out in the sixteenth century to provide a brief introduction to Vasari's (1:248) entirely fictitious "Life" of Cimabue, even though, as we have already pointed out, there was a complete lack of information about the life and career of that master. Such reports have long been viewed with skepticism, and their formulalike character has been recognized. So when one reads Carel van Mander's account (1906) of the youth of Jooris Hoefnaghel, the smooth succession of incidents leaves one in little doubt as to their origin:

> And when the schoolmaster took away his paper, Jooris would scrape together the sand on the floor and, with his fingers or a little stick, draw figures in it. And at home, hidden in the attic, he secretly made drawings with chalk.
>
> One day, Jooris made a picture of his own hand on a board. This was seen by an ambassador of the Duke of Savoy who was a guest in the house of the boy's father. The Ambassador said a good word for the boy, and so did his schoolmaster. Thereafter Jooris was allowed to draw as much as he wished [281].

This story introduces another typical motif—that of the young prodigy triumphing over obstacles put in the way of his chosen profession, often by those nearest to him. Several biographers of artists had a special predilection for

using this motif in many variations, notably Vasari, most clearly in his Life of Baldovinetti (2:522), and later Piles (1715), in the lives of Lanfranco and Mignard. Evidently this too is intended to underline—as did in its own way the story of the discovery of Giotto's talent—that true genius proves its mettle early.

While it is very tempting to go on with the presentation of biographical material, which can be traced from meager bits of information in scattered biographies to the most elaborately contrived narrations, we shall break off here and secure some of our initial findings.

The flotsam of ancient conceptions of the artist carried forward on biographical waves entirely corresponds to the attitude with which we still approach the artist. He seems to us to be a child prodigy. To delineate the area of feeling into which we have entered here, we quote a writer who had great insight into man and his emotions:

> ...and there he sat, a gray old man, looking in while this hop-o'-my-thumb performed miracles. Yes, yes, it is a gift of God, we must remember that God grants His gifts or He with-holds them, and there is no shame in being an ordinary man. Like with the Christ Child.—Before a child one may kneel without feeling ashamed. Strange that thoughts like those should be so satisfying [Thomas Mann, 1948, 177].

This observation, which springs from a rich knowledge of life, can be further supported by historical considerations. Our starting point is the fact that early biography is rarely concerned with the youth of the person whose life is being described. In a number of cases, however, youth is singled out for special emphasis. Such accounts are invariably con-nected with personages who are held in high esteem by

their environment: Hercules who strangled the snakes in
his cradle belongs to that species of heroes, just as does Plato,
of whose childhood at least one remarkable occurrence is
likewise related (though only in later times, of course).
Heathen mythology and the lives of the saints of revealed
religions are full of tales of the childhood of those whose
divine origin or special relation to the deity is beyond doubt.
From here this practice made its way into the hagiography
and even the epics of the Middle Ages, where worldly
heroes were sometimes credited with similar marvels in
their own sphere as the saints in theirs. Generalizing, one
can assert with fair confidence that every achievement
related of such exceptional children belongs to the sphere of
the miraculous: the term child prodigy (*Wunderkind* in
German) has this implication. We shall later have occasion
to draw upon a particular source to substantiate this inter-
pretation of the traditional accounts of the artist's youth,
but we already can state our view that the special position
accorded by the Renaissance to the artist, raising him to the
top of the social pinnacle, finds its visible expression in the
fact that the biographies not only paid attention to his youth
but regarded his genius as a "childhood miracle."

At this point we return to the story depicting the childhood
of Giotto, the shepherd boy. So far we have attempted to
break it down into its elements and to pursue the occurrence
of similar motifs in other biographies. Now we shall turn
our attention to the story's external frame, to the milieu in
which it is set.

To start with the most obvious: Giotto is a shepherd and
is discovered as a boy tending sheep. If we reflect upon the
role accorded to the shepherd in mythological thinking—
the representation of the hero as a shepherd, and the tradition

that makes shepherds into the foster parents of heroes aban-
doned as children—this opens up the prospect of connecting
a late anecdote transmitted by Renaissance biographies of
artists with the broad realm of myth. On the basis of this
connection we believe we can understand why the accounts
of the artist's childhood lead us so frequently into rustic
scenes and especially to his pastoral occupation. For even
though the tales of the youth of other artists may not be as
elaborate as that of Giotto's childhood, they nevertheless
report again and again that several artists were cowherds
or shepherds.

Raffaellino da Reggio deserts the geese entrusted to him by
his father (Piles, 1715, 232), while Mantegna in the fifteenth
century, and Franz Xaver Messerschmidt[2] in the eighteenth,
are both supposed to have begun life as shepherd boys (Vasari,
3:384); subsequent biographers add that they industriously drew
pictures of the animals in their herds. Obviously, these are not
facts known about the artists' lives, but represent movable scenery
inserted in the biographer's workshop. This at any rate appears
to be the case where we have other material that can be checked.
Messerschmidt, for example, who is supposed to have been a
cowherd in his native Swabia before becoming the leading
sculptor in Austria, came on his mother's side from a respected
family of Munich sculptors, who took him in when he was still
a boy—everything seems to indicate that in his case there were
no obstacles in the way of his professional choice. Even in modern
times we see occasional attempts to return to the old theme of
the shepherd boy, as in the biography of Segantini by Servaes
(1902, 12) or that of Meštrović by Planiscig (1910), who trans-
ferred the legend of the discovery of the child genius to these

2. In a rare pamphlet giving an entirely schematic account of the
artist's life. It was published in 1794 under the title *Merkwürdige Lebens-
geschichte*.

artists.[3] Sometimes the country milieu is divorced from the pastoral occupation. Giovanni da Udine, for example, whose grotesques in the Vatican loggias depict animals with great artistry and whose realism has frequently been lauded, is supposed to have shown an astonishing inclination for art as a child, according to Vasari (6:549): "When he went hunting or fowling with his father, he spent all the time he could drawing—hounds, hares, deer, indeed every kind of bird or beast that came into his hands." It is clear that here Vasari's pragmatic outlook is at work, a factor which his critics, notably Wolfgang Kallab (1908), have recognized as one of the potent ingredients of his portrayals. Whatever stands out in the subsequent achievement of an artist is traced back to the early impressions he received in childhood, about which obviously nothing is known. It therefore occasions no surprise that Vasari (1:221) himself, in the general introduction to his *Lives*, attempted to summarize and elucidate the group of tales concerning the rustic background and the pastoral occupation of artists. He wished to show that the urge to produce art was innate in and part of human nature, and that just as "our earliest ancestors, who stood nearer to the beginning of all things and the divine Creation, and were thus more perfect and endowed with that much more mental vigor, discovered those noble arts by themselves," so in more recent times one could still see "that simple children, brought up in the backwoods without education, have begun to draw by themselves, driven by the vitality of their spirit, with the beautiful paintings and sculptures of Nature as their model." This at least contains the preliminary steps in an attempt at a rationalistic explanation that we mentioned at the outset of this section; it raises in its starkest form the problem of the "factual" life, which we need not discuss again.

3. See also Ćurčin (1914, 17), Gottardo Segantini (1923, 11), Schlosser (1924, 277). Similar stories were told of Canova (Hertslet, 1905, 425) and of J. A. Koch (Musper, 1935, 101).

The explanation that we propose tries to present the outline of an overall pattern, into which both the story of Giotto's youth and its subsequent variations will fit. We can begin with the observation that in the motifs of mythology the relation of the hero to his parental home, the origin of the hero, is depicted in a very special way. This theme is dominated by the tendency to deny the real father of the man who is elevated to a hero, and to substitute a more exalted, royal parent; indeed, as far as possible, all mortal taint is removed from the hero's origin. This store of themes, which is found in a wide range of myths, is known to students of comparative mythology as the sagas of royal children who as infants were abandoned in the wilderness and later became the founders of new empires. Just like the hero who was set out as a child, the child artist is recognized by a special mark. But the discoverer of the child artist is sometimes vested with a dual role. Cimabue both discovers the shepherd boy and becomes his teacher—his new, elevated father. Here we must relinquish the further pursuit of the parallels between individual themes and the detailed exposition of findings and suppositions of comparative mythology, but we wish to emphasize one point. The theme of the social rise of the artist, a biographical formula whose roots go back to Duris of Samos, and the theme of the obstacles that the genius has to overcome, appear in a new light when we compare them with incidents which frequently depict the hero who started from a poor and menial position embarking on his triumphal progress in the face of all adversities of fate.

In attempting in this way to link up the themes of an anecdote about artists with those of myths, we are doing no more than following a lead that was given in the most general terms a long time ago, though it was never seriously

pursued. For when the anecdote is characterized as the "younger sister" of saga, traced back to the same formative elements, and only ascribed to a different sphere of operation (Bernheim, 1903, 467); or when we hear that "as the spiritual condensation of the diffuse," and "in relation to the basic disposition of the human mind from which it derives," the anecdote is identical with myth (Löbell, 1859)—then we are offered an interpretation which readily fits the particular case that we are using to prove the connection. The area staked out by this interpretation is wide enough to embrace biographical formulas, which, as in the case of Duris, the historian uses as artifical devices for a particular purpose. The legend of Giotto's childhood has an entirely different origin; it has no identifiable source other than popular tradition handed down by word of mouth. The critical examination of sources as practiced by the historian performed its task when it was able to trace back a legend to these roots, as was the case in Wickhoff's study (1889). The next step required the employment of methods regularly used in the comparative study of sagas and fairy tales, in the study of those great "secular dreams of mankind" (Freud, 1908, 152) which are regularly traceable to a common conception, despite the differences of meaning and significance of particular themes—a circumstance that serves to demonstrate the universal diffusion of such "dreams." These fantasies are deeply rooted in the mental life of man. They repeatedly prove their capacity to become the vehicles of the most diverse realizations, thereby pointing to the roots from which the concatenation of themes and links between them can be understood. We may now add in a few words what modern psychology has been able to contribute to this topic. It teaches us that those motifs of fairy tales that live

on in so many disguises in the consciousness of man regularly appear anew in the fantasies of children; and that those other themes found in sagas and myths are perpetually revived in the dreams of civilized men—the immediate derivative of his unconscious. Finally, to return to the particular concerns of this study, it has proved possible to establish a parallel to the group of motifs that deal with the youth of the hero in myth, legend, or anecdote, in a common but secret fantasy of children and adolescents for which the term "family romance" has been adopted (Freud, 1909; Rank, 1909). Leaving aside the question of the psychological motives of their causation, the core of these fantasies is simply the child's notion that he is not the child of his parents with whom he has come to live by this or that fluke of fate, but is in fact of higher birth, an unrecognized hero who still may hope to be discovered.

On the basis of this psychological foundation we can understand that the anecdote concerning Giotto's youth itself functioned like a motif of mythological thinking and thus was able to migrate far afield. One has the impression that it expresses an intensely satisfying idea of the youth of artists—an idea that for this reason was capable of wide diffusion. For the same reason it sometimes seems to have caught the imagination of poets. We encounter it in Hans Christian Andersen's tale of the Bronze Boar, in which a Florentine street urchin has taught himself to draw; his gifts are discovered when he is found tracing the likeness of a lapdog in his foster father's house where he lives in miserable circumstances. This motif is so immensely potent, however, and corresponds so exactly to the popular notion of how artistic genius comes about that it did not remain confined to the area of the visual arts. In Octave Feuillet's *Dalila*

(act 2, scene 5) the story is told of how the Chevalier Cornioli discovered the hero of the play, Roswein, a musical genius, as a child in Dalmatia. The boy was an orphan, covered in rags; his only possession was a violin, and his only companion was a goat called Sylvia, from whom he refused to part. This brings us back to another motif of mythology, for it has long been a familiar aspect of human imagination occasionally to regard animals as the guardians and caretakers of favored heroes.

Deus artifex— Thus far we have dealt with
divino artista just a few of the themes found
in ancient and more modern
biographies of artists. Now we propose to view them from a broader perspective, which entails both reexamination and further elaboration. The legend of the discovery of the young Giotto has characteristics that in myths are frequently associated with accounts of the youth of heroes. The nucleus of their agreement evidently lies in the predestination of the child artist to achieve future greatness. All the chance events that lead to his discovery, and thus to his brilliant ascension, appear in the biographical presentations as inevitable consequences of his genius. The miracle of being an infant prodigy is itself merely an expression of the special favors bestowed upon him.

The lack of similar information about artists in ancient Greece or Rome does not warrant the conclusion that this mark of singularity was not accorded to the artist by classical antiquity, because the paucity of existing sources raises doubts about all conclusions based on their silence. In this case, however, we have direct evidence. We know that classical antiquity did not credit painters and sculptors with

"singular or special genius." Here we touch on a question which has often been debated, yet in many important particulars still awaits a solution.

The social position of the artist in the Greek city-state was still a very limited one; it was characterized by "lack of independence, half of the rights before the law, and an uncommonly low estimation of his rank" (Schweitzer, 1925). This tradition has been handed down from earliest times and was codified, for instance, in the Homeric epics. This low estimation appears in the guise of two formulas. The first expresses disdain for the work of painters and sculptors because it is manual labor, which, as a brilliant modern writer (whose premises, however, we cannot accept) has pointed out, was "in a slave-based economy" left to the members of a servile class (Zilsel, 1926).

To establish the general validity of this factor one must be prepared to assume, as Zilsel does, that all the insults, malign gossip, and mild contempt to which Homer's Hephaistos was subject are attributable to the fact that this highly artistic metal-worker labored with his hands. Regardless of whether or not one accepts this explanation as the original cause of the social rejection of the artist, it played a significant role in classical antiquity and, for example, figured prominently in Lucian's famous "dream." Even in the Renaissance, it is occasionally revived, especially in references to the competition of and rivalry between the arts. If in these tediously repetitious disputations in the art literature of the Cinquecento, painting occasionally wins out over sculpture, the decision is sometimes defended by the argument that painting requires less physical effort than sculpture.

The second formula derives from the tenets of art itself and has, in Plato's formulation, achieved enduring significance: art as *mimesis*, as the imitation of nature, can provide

only a distant reflection of true being, of ideas, which art attempts to reproduce at second hand, as it were, by imitating their earthly embodiments.

It was only in the fourth century B.C. that a significant change in the estimation of painters and sculptors began to occur. This is seen most clearly when artists gradually become the subjects of biography. In the writings of Xenocrates and Duris, so far as they can be reconstructed, we can detect signs of this new appreciation of the artist. This "revolution in classical attitudes toward both the graphic arts and their practitioners" (Schweitzer, 1925) accounts not merely for the existence of artists' biographies but also for several of their characteristic features. They show us the artist at the height of his newly acquired fame, frequently in most intimate contact with princes and rulers, toward whom he comports himself proudly and at times even dismissively. The keynote of such portrayals seems to be that the artist confronts the princely layman—who here stands for all laymen—as an expert.

It is typical of a group of these reports which again are linked with Duris (Sellers, 1896, lxi) that Apelles unmercifully hounds Alexander for his foolish remarks about art, and that Alexander cedes his own mistress, Campaspe, to the lovesick artist; or that Demetrios spares the besieged city of Rhodes so as not to endanger the life of Protogenes (Pliny, 35:85–86, 104–06 [see also Reinach, 1917]). Another set of reports is concerned with the pride of artists: Parrhasius called himself a prince of art; Zeuxis gave his pictures away, because he could not sell them at a respectable price; and the same artist was notorious for the splendor of his clothing—at Olympia he wore a cloak that had his name in golden letters woven into its borders (Pliny, 35:71; 35:62).

In the Renaissance the message of these anecdotes became an

influence upon conduct; the halo of their classical origin made them into exemplars and lent them impetus. It was to them that the artist owed his awareness of his own worth—indeed, it was stressed over and over again that in ancient times the artist's achievements were held in much higher esteem, while the prince for his part saw in Alexander the model of the ruler who in no way demeans himself by paying deference to genius. When, in one of Bandello's *Novelle* (no. 58), Leonardo is provoked by the disparaging tone of a cardinal into telling the story of the surrender of Campaspe, he regards himself as a second Apelles, just as Charles V in his dealings with Titian feels that he is another Alexander (Ridolfi, 1:181).[4] Moreover, we hear echoes of the classical tradition in which artist and prince confront one another as equals in what Francesco da Hollanda (1928, 12) relates of Michelangelo's relationship with his papal patrons, notably Clement VII; in what was told of Donatello's relationship with the Patriarch of Venice (Wesselski, 1929, 27); and of Dürer's with the Emperor Maximilian, who gets a nobleman to hold the ladder for Dürer while he paints (Mander, 1906, 430 [correcting his original version on p. 37]); and of Charles V's retrieving Titian's brush for him (Ridolfi, 1:180).

These derivatives of classical sources have taken us far beyond our point of departure, to which we return. All the high esteem expressed in Hellenistic biographies that put artists on a par with princes never quite succeeded in silencing those who voiced mistrust of, or even contempt for, art as a profession. The evidence for such an attitude is found in the writings of a Lucian or a Seneca. "One venerates the divine images, one may pray and sacrifice to them, yet one despises the sculptors who made them" (Zilsel, 1926, 27). The distinction that is here drawn between the artist and his

4. See Winner (1962) on Apelles and Campaspe in Renaissance and later paintings.

work is not exclusively or even chiefly attributable to the work of art serving a religious rather than an aesthetic function. Nor did the undisputed appeal of works of art succeed in dispelling the mistrust of the artist's station: "For even if a thing charms us, it is nevertheless not necessary to desire to emulate its creator" (Plutarch, *Pericles*, chap. 2). Only a sample of such opinions need be given here to round out the material contained in the biographies. In spite of the fact that they portray painters and sculptors and architects as the friends of princes, they succeeded neither in banishing doubts about the social position of artists nor in bringing about a fundamental revaluation of the artist's achievements. The Greeks did not listen to their claim to a higher place in the ranking of creative accomplishments. If we cursorily survey the findings of the extensive and carefully interpreted researches on the subject—foremost among them the investigations of Schweitzer (1925) and Pöschel (1925)[5]— we may say that the painter or sculptor continued to be seen as banausic, entirely lacking the divine inspiration that, according to Plato, was granted to the poet. The latter was an "instrument of the deity," graced with genuine inspiration and endowed with enthusiasm. As Plato indicated in his *Phaedrus*, the idea of the divine possession of the poet sprang from religious practice; it is an offshoot of the belief that the predictions and auguries of priestesses and prophetesses are fulfilled by "divine madness." This divine ecstasy is ascribed to the poet and the rhapsodist, but is denied to the painter or sculptor (Plato in *Ion*). In contrast to the "enthusiasts," he— like the military strategist, the doctor, and the charioteer—

5. See also Dornseiff (1936, 19), Kristeller (1951–52, 502f.), Otto (1956, 38f.), and Bianchi-Bandinelli (1957, 1–17).

performs his work "with the aid of skill [τεχνη] and knowledge." Another prerequisite of his activity is his φυςις or natural endowment. These two elements are reminiscent of those found in the account of Lysippus's choice of profession for one can connect teaching oneself and natural endowment, and associate the traditional linkage of a genealogical succession of teachers with the principles of art. The self-taught artist represents the exceptional case of one whose accomplishment is due primarily to natural endowment.

Alongside the view that regards the painter or sculptor as a mere imitator of nature and therefore holds him in low esteem, there already existed in the fifth century B.C. another view which, it is true, seems to have had little effect on the social prestige of the artist in antiquity, but which decisively shaped subsequent developments. While the first maintained "that the work of art is less than nature, in that at best it can only imitate it to the point of deception," the other maintained "that the work of art is greater than nature, in that it makes up for the deficiencies of nature's individual products, which it confronts with a newly created and independent image of beauty" (Panofsky, 1924). The best known formulation of this view is found in Xenophon's Socratic *Memorabilia* (III, chap. 10, i–iv). In a conversation with the painter Parrhasios, Socrates defines the task of art when he asks whether the artist who finds difficulty in discovering a flawless person as a model might not combine the beauty of individual features, which are found in many people, in one entirely beautiful body. This view corresponds exactly with Plato's opinion (*Republic*, 472D) that the painter does not need to prove that the beautiful beings he depicts in his works exist in reality. This viewpoint, too, in the form of an anecdote, made its way into biography.

When Zeuxis was in the city of Croton to paint his portrait of Helen, he chose five virgins, in order to copy the finest feature of each. This tale, which was cited frequently and in many variations even in antiquity (Overbeck, 1868, nos. 1667–69), found its way into the world of medieval thought, formed the conclusion of a charming novella in the *Gesta Romanorum* (Floerke, 1913, 337), became a permanent feature of Renaissance biography, and can even be found outside art-historical writings, for example, in Ariosto's *Orlando Furioso* (canto XI, v. 71).

We have before us here the basis upon which a new outlook toward the artist was to arise. Having been expressed clearly in the art theory of the late classical period, it was raised to the status of dogma in the philosophy of Plotinus. In a passage devoted to Phidias's Zeus, he asserted that the operations of the imagination, the inner vision, were of greater moment than any imitation of reality. Phidias, he claimed, depicted Zeus as the god himself would appear were he to be inclined to reveal himself to the gaze of humanity. According to the tenets of Plotinus's metaphysics, the image of Zeus that Phidias carried within him was not a representation of Zeus but his essence (Panofsky, 1924). This assertion paved the way for a revised judgment of the artist, who now took his position as an equal with the other creative persons—the poets who even in antiquity had been revered as seers.

Thus Callistratos saw the influence of the gods not merely in the voice of the poet, but also in the hands of the sculptor; they too were divinely inspired to create. That these are harbingers of a new attitude finds confirmation in the fact that early sources preserved by a Byzantine lexicographer (Suidas) explicitly credit

Phidias and Zeuxis with "genuine enthusiasm" (Overbeck, nos. 1164 and 800).

Yet this conception of the artist failed to achieve concrete expression either in biography or in his social esteem. By the time it was fully formulated, the flesh-and-blood figure of the artist prevalent in classical antiquity had long since faded away and had retreated into the shadows of an anonymity symptomatic of a new formal and intellectual approach to art. However, the image of the artist as it evolved in late antiquity was never entirely lost in the Middle Ages, and was revitalized in the Renaissance when the artist once more became the object of biography. Even the genius of the boy Giotto, the inner voice which speaks in his first endeavors, partakes of this legacy. From now on whatever emerges as a typical feature of the descriptions of artists' lives can be associated, trait by trait, with this basic conception of the artist's genius. This attitude is of course most clearly discernible when we are in a position to compare it directly with that of classical antiquity. An example that lends itself particularly well to clarification by such comparison concerns a strange and impressive circumstance— one that has long engaged man's imagination: not art alone, but chance as well, sometimes succeeds in producing objects that appear to be meaningful and to have been created intentionally. This motif is frequently referred to in classical biographies of artists.

Protogenes is supposed to have tried in vain to depict the foam forming on the jaws of a panting dog; in sheer frustration he threw his sponge at the picture—and the sponge created the desired effect. "Fecitque in pictura fortuna naturam" (Pliny,

35:103; see also Sellers, lx and 232). Similar stories are told of
Apelles (see Dio Chrysostom, *Orations*, 63:4, cited in Overbeck,
no. 1889; for the veracity of this, see Sauer, 1917–18, 536), and
also of Nealkes (Overbeck, nos. 1907, 1.24 and the introduction
to no. 2103); in all these cases the prime consideration is that
chance comes to the aid of the painter. These stories, which are
widely scattered in numerous classical sources, probably origi-
nated in a comparison of the effects produced by chance and those
created by the artist. In Renaissance biographies this phenomenon
was seen in another light. According to Vasari (4;134), Piero di
Cosimo would sometimes stop and "stare at a wall onto which
sick people had vomited, and out of it conjure up for himself
battles between mounted horsemen and the strangest cities and
vastest landscapes ever seen. He did the same thing with clouds."
Here it is a chance configuration that affords the artist the oppor-
tunity to give free reign to his imagination, to see figures in
fortuitous arrangements. One might easily imagine that this
happened to be an idiosyncrasy of Piero, whose personality as
Vasari depicts it abounds in bizarre traits. But what Vasari reports
about Cosimo's attempts to read meaning into chance formations
had a recognized place in contemporary thought. In his notebooks
Leonardo recommended that the artist interpret damp spots on
the wall in order to exercise his imagination and keep it alive.
And it is not too far-fetched to suggest that Piero, who we know
was artistically dependent on Leonardo, may also have gotten
the idea for adopting this practice from him (M. Herzfeld, 1926,
146; see also Leonardo, 1956, part II, cap. 93).[6]

Leonardo's recommendation is not an isolated incident. We
become aware of how extraordinarily widespread these connec-
tions are when we learn that the eleventh-century Chinese
painter Sung-Ti advised Ch'ên Yung-chih to create a picture of a
landscape in accordance with the ideas suggested by a tumbledown

6. Compare Leonardo (1939, 1:311); see also Armenini (1587, 193),
Janson (1961), Harris (1969, 22), Du Gué Trapier (1940, 13).

wall. "For then," he said, "you can let your brush follow the play of your imagination, and the result will be heavenly and not human" (Giles, 1905, 100).[7]

Whereas classical biography puts chance configurations on a par with the products of the artist, to which they may also happen to contribute, in Leonardo's conception they were means of training the artist's fantasy and creative forces. Goethe expressed a similar thought in connection with another group of chance configurations—clouds:

> The mind's own power to shape now boldly wakes,
> As definite from indefinite it makes.
> [Nun regt sich kühn des eignen Bildens Kraft,
> Die Unbestimmtes zu Bestimmten schafft.]
>
> *Howards Ehrengedächtnis*

(For those who enjoy historical perspectives we might add a further link in the chain. The practice recommended by Leonardo as an exercise of the imagination has been taken up by modern experimental psychology—in Rorschach's form interpretation test which uses chance configurations made by ink blots. Here a tendency of the human mind is utilized to provide a statistical basis for psychodiagnostic purposes.)

This emphasis on the artist's imagination was also responsible for the new heights to which Renaissance art theory raised the artist's accomplishments. The Cinquecento no longer regarded the imitation of nature as the acme of artistic achievement, but rather viewed "invention" as its foremost aim. It no longer valued "diligenza e fatica delle cose pulite," the diligence and labor expended upon careful

7. In Japan Hokusai once drew "the curves of a mighty river. Then, dipping the feet of a cock in orange-red, he allowed the bird to walk over his design, and so brought to the mind of all his beholders the famous river Tatsuta, with the maple leaves of autumn floating on its stream" (Strange, 1906, 9).

execution; its new measure of appreciation was "il furore dell'arte," artistic ecstasy. This view gained wide diffusion in Vasari's formulation at an early time, but could in fact be traced back to the theory of art propounded in what remains of Aretino's writings (Venturi, 1924).

This point of view also decisively influenced the evaluation of the work of art itself. The new interest in drawing as the earliest evidence of the creative process emerges during this period; and it is no coincidence that Giorgio Vasari, one of the first literary proponents of this new appreciation of the artist, should also have been one of the earliest collectors of drawings. Here we shall not pursue in detail how this new appreciation of sketching was reflected in the development of Italian art, nor shall we examine the methods by which as late as the eighteenth century certain groups of art works can be distinguished solely by the degree of their finished execution. Soon, however, the unfinished was highly appreciated in its own right; and the strange statement found in guidebooks to Florence, that Michelangelo's unfinished slaves in the grotto of the Boboli Gardens are in that state more beautiful and more impressive than if the master had completed them, is nothing but a reflection of the same aesthetic that has continued to exert its influence to this day (Kris, 1926). This is in complete contrast to what was valued in the Middle Ages which used as the aesthetic yardstick the degree to which a work was finished in the sense of craftsmanship. This illustration of divergent views demonstrates the intimate links between the criteria on which aesthetic judgments are based and the role and esteem accorded the artist by society.

The new image of the artist which evolved in the sixteenth century found its clearest expression in the opinion that "wonderful and divine thoughts" come into being only when ecstasy complements the operation of the intellect (Vasari, 2:204). This is at the same time a reminder which

leaves no doubt that artistic creation rests upon inner vision, upon inspiration. Thus, inevitably, there emerged an image of the artist who creates his work driven by an irrepressible urge, in a "mixture of fury and madness" akin to intoxication. This idea has its roots, as we have attempted to indicate, in Plato's theory of art; but it was not until the Renaissance that painters and sculptors were credited with possessing genuine ecstasy. Thus transformed into "the stylus of god," the artist himself was honored as a divine being. The "religion" among whose saints he is counted is the modern-day worship of genius.

In a book that is basic to modern art history Erwin Panofsky (1924) has demonstrated that the idea of the inner voice of the artist is rooted in Platonic and neo-Platonic philosophy, and he described the ways in which the concept of the "idea" dominated the theory of art. He has shown that "ideas," which "in Platonic doctrine have absolute being in every respect," were ultimately transformed, in a process that culminated in the writings of Saint Augustine, "into the thoughts of a personal God" who creates the world in accordance with a divine idea. When Dürer speaks of the painter "being inwardly filled with forms [*Figur*]"—echoing Seneca's statement that God "plenus his figuris est, quas Plato ideas apellat" ("he is filled with these shapes, which Plato calls 'Forms'")—he is combining this view with that of divinely conferred inspiration. The adulation of the divine artist runs like a thread through all biography since the Cinquecento. This notion was permanently fixed by another remark of Dürer's, who characterized artistic activity as "creating just as God did"; an Italian parallel is Alberti's designation of the artist as *alter deus*. This became the dominant theme of art theory; we encounter it in one form or another

so frequently that we no longer can survey its many trans-
formations. What the biographers attempt to present is
best described in the artist's own words. Leonardo (1956,
parte I, cap. 35), for instance, calls the painter, who summons
at will beautiful, terrible, or droll things into this world,
"signor e dio," lord over these creations of his. That "certain
image of beauty" that Raphael carried within him (as he
confessed in an incomparable letter to Baldassare Castiglione)
may likewise be taken as evidence of this new outlook, as
may Michelangelo's conception of a world of figures which
he merely liberated from the marble.

In drawing attention to this attitude we find ourselves
back at the starting point of our investigation, for the inner
voice in which we again recognize divine ecstasy, the
"enthusiasm" of the Greeks, can already be heard in the
story of the discovery of Giotto. It is in accord with this
notion that in the Renaissance we witness the prevalence
of the view that artistic creativity is determined not by
schooling or practice, but by a special endowment, the $\phi v \varsigma \iota \varsigma$
of the Greeks. This view appears as the formulation that the
artist is born an artist.

The literature on art and artists is steeped in this assumption.
Mander (1906), who puts words of high praise for Geertgen tot
Sint Jans into Dürer's mouth, has him say, "Truly, he was a
painter in his mother's womb," adding that "by this he intended
to say that he was destined to be one by nature before he was
born" (p 41). In Francesco da Hollanda's *Dialogues* we often find
the assertion that the true painter is so born—nobles can be created
by the Emperor, but painters only by God (p 15). Thus formulated
this idea emerges simultaneously in a host of anecdotes, all of
which use this device to proclaim the special position of the artist;
one instance is Mander's biography of Holbein (86ff.). The artist

becomes embroiled in an argument with an English earl, whom he throws down the stairs of his house. When the earl complains to the king, he receives the answer, "I'll tell you this, my lord, if I so fancied, I could make seven earls out of seven peasants, but never a Hans Holbein out of seven earls." Mander used similar words in his description of the lives of Dürer and Goltzius (37 and 371) as did Passeri (1772, 75) in that of Guido Reni. One might mention that a distant version of the same thought can also be found in Johannes Pauli's book of jests (1:72) where, in a competition between knight and doctor, the latter plays the role usually assigned to the artist.[8]

While all these and many other allusive or discursive accounts seek to underline the special position of the artist by referring to the divine origin of his genius, the divinity of his birth was also more directly asserted in biographies. Occasionally, this appears in connection with the belief in astrology, that most important repository of surviving classical thought. Such a view occupies a central place in Vasari's life of Pierino da Vinci (6:120), whose splendid future was predicted when he was a child of three by an astrologer and a palmist.

The portents of a special astrological constellation also marked the hour of Michelangelo's birth. In Vasari's words (7:136), "Since God saw that it was just in Tuscany that sculptors, painters, and architects devoted themselves most diligently to the noble arts . . . , He desired that this spirit that He sent out should have Florence as its home."

At this point the biographer becomes a prophet, and the life history assumes the qualities of a myth. "This son, of

8. Luther (*Werke*, 44:657) attributed the same saying to the Emperor Maximilian I.

whom I am speaking, was born on March 6th, a Sunday, toward eight o'clock in the evening. He was given the name of Michelangnolo. Without further reflection, as if under the influence of higher forces, one thereby wished to signify that he towered above every human measure, and possessed heavenly and godlike gifts."

Birth is here depicted as in a myth. The word-play of the naming is exploited to portray the feelings of those standing around the cradle. It is consistent with the structure of the myths and the succession of their motifs when next we hear that the boy was brought to Settignano, where he was nursed by a stonemason's wife, so that Michelangelo, as he himself is subsequently supposed to have reiterated, "sucked in the attraction to hammer and chisel with the milk of his wet-nurse."

The premonitors that dominate the preface to Michel-angelo's life necessarily recede into the background in the subsequent course of events, but the sense of pathos with which not only Vasari, but other historians as well, narrate the life of the great master reaches beyond the domain of biography.

If we glance back at the legend of Giotto's youth and relate it to this report of Michelangelo's birth, we become aware of the factor that distinguishes this view of the artist from that of the Greeks: the myth of the hero has now been joined by a myth of the artist. It is true that this myth did not evolve into a set form of its own under the probing glare of modern Western culture, but it is woven into the fabric of biography. The heroization of the artist has become the aim of his bio-graphers. Historiography, having once accepted the legacy of myth, is never fully able to break its spell.

Yet, the glorification of artistic genius in the Renaissance

cannot be explained solely in terms of the causes that we have so far uncovered. Alongside the art theories prevalent in classical antiquity we now have the concept of God the Creator, whose work was regarded as that of an artist.

We can distinguish two groups of ideas: God as the builder of the world, and God as the modeler of man. In the first, God is seen as engaging in two crafts. The figure of God the Creator as an architect first appeared in Babylonian texts, and as that of a smith in Indo-Germanic mythology. Ancient Indians, Greeks, and Germanic people all conceive of heaven as an iron vault. While we cannot pursue the forms in which these two conceptions persisted, we want to mention that the idea of God as the world's architect underlay the mystic tradition of the medieval lodges, and that the idea of the divine smith was still alive in the natural philosophy of the sixteenth century, its renunciation of anthropomorphism notwithstanding. "Everything in nature is endowed with a sidereal emanation called the firmament or astrum, even the hidden smith and master of the workshop, who causes form, structure, dimension, and color to exist" (O. Crollius, probably following Paracelsus; see Schlegel, 1915, 11). The most widespread image, however, is that of God who, like a sculptor, forms mankind out of clay. The biblical creation story, through which this idea became the common property of Western thought, has parallels in an analogous Babylonian myth in which mankind is made out of blood and clay (in Jeremias, 1930, 45ff.); and in the Egyptian tale of Chnum, who formed the body of the child and his *ka*, or guardian spirit, on his potter's wheel, whereupon Heket, the goddess of birth, breathed life into these earthen figures (Erman, 1923, 61; and Sethe in Pauly, vol. 3, col. 2349). In more recent times, some attempts have been made to demonstrate the presence of similar ideas among primitive tribes, especially those of south-east Australia. The concept of a divine being creating men out of clay is indeed widespread among these people and, in the opinion of many researchers, antedates any possible

influence exerted by missionaries. (In this case one would have to accept that this belief was intimately associated with the primitive monotheism that Schmidt and Koppers (1924), the originators of the theory of cultural spheres, are inclined to see as one of the earliest manifestations of man's religious beliefs.) The universality of this myth and its repetition in almost identical terms make it readily understandable that it was ideally suited to become the vehicle of ideas that are deeply rooted in the emotional life of man.

As Panofsky has shown, two conceptualizations had their origin here. In one, God is compared with the artist—the means by which "the Middle Ages were accustomed ... to render God's work of Creation comprehensible"; in the other, prevalent since the Renaissance, the artist is compared with God—a comparison that subserves the aim of "heroizing artistic creativity." The medieval concept is rooted in the Bible, but owes its refinements to late classical thinkers.

Over and above its usefulness as an elucidation of the divine processes of creation, the metaphor of God as an artist possessed an inherent cogency that enabled it to function as a testimony to the existence of a Creator, whether in the Old Testament (Isaiah, 29:16), Greek (Empedocles, cited by Diels, 1922, 1:234), Gnostic (Poimandres, 5:8), or Christian literature (Singer, 1939, 33). It thus emerges as the forerunner of the cosmological proof of God's existence, which argues from the conditionality of all that is to the existence of a first cause. In a similar vein, the "physio-theological" proof of God's existence, as Kant called it, argues from the rational structure of the world—comparable to the "articulation of a fabricated construction"—to the existence of an "architect of the world." "But at any rate we must admit that, if we are to specify a cause at all, we cannot here proceed more securely than by analogy with those purposive productions of which alone the cause and mode of action are fully known to us" (Kant, 1781, 522).

If, says Athanasius, a work of Phidias is identifiable without a label because of its harmony and correct proportions, this must apply even more to the world as the masterpiece of the Greatest Sculptor (Borinski, 1914, 1:69). This idea lives on in medieval literature right up to the time of Nicholas of Cusa, who describes God as if he were a painter mixing various colors, so that ultimately He can paint Himself and have His own likeness, "whereby His art is satisfied and finds peace" (*De visione Dei*, chap. 25). This idea already permeates the early art literature, from Cennini onward, still persists in the sixteenth century, and even becomes the object of the arts themselves—in the delightful painting, for instance, in which Dosso Dossi portrayed Zeus as the painter of the world (Schlosser, 1927, 296).[9]

As a late offshoot of this tradition, one might mention the popular treatises on arts and crafts in which, since the earth is round, God is called the First Turner (Teuber, cited by Ilg, 1881, 9); or the compilations (drawing on the Bible) of the catalogues of the works of God the Father, Christ, and the apostles (for example, in the very curious piece entitled "Well-taught Narrative Writers and Painters Experienced in the Arts," by Dauw).

In the Renaissance the idea of God's artistry passed into that of the artistry of Nature. We encounter it as early as in the writings of Leone Battista Alberti (1404–72). Contemplating the strange shape of some marble fragments, he expresses the thought that it looked as if at times Nature delighted in painting (see Ilg, 1881, 11ff.)[10] In the seventeenth century, however, admiration for "Nature as the artist" extended even to the practice of art itself. Selecting one idea from among many found in the cabinets of

9. The picture is in the Kunsthistorisches Museum, Vienna. See also Klauner (1964).

10. See also Baltrusaitis (1957, 47–72) and Janson (1961, 254ff.).

rare arts and curiosities, we can cite the fashion of painting on
marble as a characteristic example. Only a few portions of the
slab were given over to the brush, and every effort was made to
use the natural stratification of the marble in the composition
of the painting.

The tales of the cultic objects that came into being by "their
own devices" marginally touch upon the problem raised here.
There is a line starting in heathen antiquity when the Palladia
fell from heaven to the images of Christ produced by contact
with the face of God (Veronica's handkerchief), as Dobschütz
(1899) has shown. Similar themes can be detected in the Lamaistic
literature of Tibet (Laufer, 1913, 254ff.), which also contains
references to the painter's inability to depict the face of God and
to miraculous likenesses.

The idea of God's artistic greatness can be pursued in
several different directions. One that immediately comes to
mind and attests to the significance of this concept is a story
told about El Greco. The power of his pictures to stir the
emotions was due to his having broken the arm off a crucifix
with the aid of which he then painted (Roessler, 1924, 74).
Here we see God's own hand actually put to the work of
art—in the form of a magical superstition. In an indirect
form, Fra Angelico professed the same belief, according to
Vasari (2:520). It was his custom never to improve or
retouch anything that he had painted, but to leave it as
it first emerged from his brush, since, as he is reported to
have said, he believed that God's will was thus done. In the
same range of ideas are stories relating that the artist was
singled out by God to execute a particular work or destined
for an especially important mission, thereby enabling him to
carry it out. We read, for instance, in Exodus (35:30–35)
of the artists chosen to direct the making of the tabernacle,

"See, the Lord hath called by name Bezaleel the son of Uri . . . and he hath filled him with the spirit of God, in wisdom, in understanding, and in knowledge, and in all manner of workmanship . . . both he and Aholiab the son of Ahisamach." The calling of these biblical artists and their infusion "with the spirit of God" can be directly compared with the Greek concept of inspiration; in the biblical account, this is still firmly embedded in the actual cultic activity, from which it steadily emancipated itself in Greek thought. In the sphere of religion, this notion survived unchanged for a long time.

The story that an angel revealed the structure of the Hagia Sophia to its architect in a dream belongs here (Mordtmann, 1922), as does the legend of the skillful monk Tuotilo, whose work was finished by the Virgin Mary (Schlosser, 1892, 417). The divine personage demonstrated her artistic ability by aiding the artist, but her help is contingent upon a character trait of the artist—his piety. St. Luke painting the Madonna is the progenitor of numerous others enjoying the same privilege (Dobschütz, 1899, 278); even as late as Michelangelo, we hear that the Queen of Heaven herself posed as the model for his statue in the Medici Chapel (Doni, 1928; Thode, 1908, 4:507). While in this case one cannot mistake the influence exerted by the tale of Zeus posing for Phidias, in the case of Guido Reni it is explicitly stated that the Madonna appeared to him on account of his piety (Malvasia, 1841, 2:53).[11] A popular version of the same idea occurs in medieval legends. There the painter who with an ailing hand portrays the Madonna recovers his health at the first brushstroke; or the artists who endeavor to concentrate all beauty in the figures of Christ and the Virgin thus provoke the hatred of the Devil;

11. Buddhist legends tell of an artist who was taken up to Heaven so that he could see the Maitreya Bodhisattva and make an image of him (Giles, 1956, 9; Wegner, 1929, 167).

the latter attempts to topple the painter from the scaffolding, but the Virgin comes to his rescue (Ilg, 1871, cli; 1881, 37 [see also Odenius, 1957; Tubach, 1969, no. 3573]). Buffalmacco's words, "we painters always make the Devil horribly ugly and, what is worse, we do no more than to paint saints on walls and panels to make people better and more devout, so as to spite the Devil" (Sacchetti's *novella* 191; Vasari, 1:500), refer in jest to the same theme to which Christian Morgenstern still devoted his poem "The Painter." The Devil's intervention must be understood as the counterpart of divine intervention. He too helps the artist at his work, but not as the creative spirit and designer; he performs manual tasks, speeding the execution and enabling especially the architect to finish his work on time (Ilg, 1871, cil; Kinkel, 1876, 186ff.). In a typical version of this motif, the artist pledges his soul to the Devil, a legend that was still told about Messerschmidt as late as the eighteenth century (Kris, 1932, 224). In other versions the pious builder compels the Devil to serve as his assistant, as St. Wolfgang did when he erected a church (of whom there is a lovely painting by Moritz von Schwind in the Schackgalerie in Munich); or, in a much earlier legend, King Solomon forced the demons to assist him in building the Temple (McCown, p. 69). In the Swedish saga of the building of Lund Cathedral—a saga that has affinities with the fairy tale of Rumpelstilsken—a heathen giant takes the place of the devil (Gyllander, 1917, 213 [Puhvel, 1961; Boberg, 1955, 8ff.]).

In these legends the image of *deus artifex* which culminated in the concrete representation of an artistically active deity or one who collaborates with or aids the artist corresponds to the image of the divine artist, an image that has continued to recur since the Renaissance. In the fifteenth century Leone Battista Alberti described the artist's activity as that of a "second God," and in the sixteenth century Aretino was one of the first to use the words "persona divina" in ad-

dressing Michelangelo and the much-quoted phrase "divine paint brush" of Titian. The attribute "divino," first bestowed on Michelangelo and other artists, has found its way into ordinary language and has become an automatic figure of speech. It is still used today in the epithet "diva" applied to opera singers and actresses.

Biographical accounts such as that of Michelangelo's birth by Vasari derive from the same group of ideas. In these the birth of the divine artist is presented as the birth of a son of God. Here the belief in the actual identity of what is being compared can to some extent be discerned.

This need occasion no surprise when one reflects that in the Renaissance the idea of genius also had two meanings. On the one hand genius was simply used to designate the category of an individual's mentality, while the second meaning becomes clear, for example, in the Poetics published in 1561 by Scaliger who believed that a poet's genius possessed an external existence (Zilsel, 1926, 285). The idea of the creative powers of the *divino artista* is, however, inseparably linked with the idea of genius. We have attempted to show that the Renaissance took this idea from what was transmitted of the Platonic theory of art and gave it new life; and we believe that the story of Giotto's youth can be regarded as the first evidence for the correctness of this interpretation.

In conclusion we should like to point out that several individual themes of this legend can be explained in terms of their particular origin. The myth of the creation of the world early emancipated itself from the sphere of religious ideas in which it was rooted, and became subject to the formation of a series of new legends. Among the many Gnostic apocrypha that became attached to the Gospels,

there is one that portrays the Christ child Himself as an artist (The Infancy Gospel of St. Thomas; see James, 1924, 49).[12] The Savior models birds of clay, which take wing at his command. (This theme inspired the Swedish writer Selma Lagerlöf to write her *Christ Legends,* an imaginative story of great psychological subtlety.) In the apocryphal gospel this theme is combined with features that characterize the childish miracle worker as a magician, as an evil, malevolent, and all powerful sorcerer.

This apocryphal account was known in fifteenth-century Florence, and it is tempting to assume that the theme of the artist's fabulous childhood owed some of its features to that account. Oral tradition born of popular imagination soon mingled with other motifs, in which we believe we can recognize features of other myths. Thus the childhood miracle of Jesus, which shows us the Savior as a young sculptor who playfully copies sparrows in clay and summons them to life, forms the bridge between the ancient conception of an artist god—the Lord of Creation of the Judaic tradition —and that of the artist child, whom we encountered at the beginning of biography in more modern times.

12. See also the Koran (3:48 and 5:10).

3

The Artist as Magician

The Work of Art
as a Copy of Reality

The evaluation of the artist's achievement seems to depend to some extent upon a comparison between the work of art and nature, even though the connection may at times be so remote that it is not consciously perceived. This comparison proceeds from two opposite points of view. One of them can be summed up by the anecdote about Zeuxis. Painting his picture of Helen, he selected the most beautiful feature of five different girls and incorporated each into his portrait. The conception on which this anecdote is based views the task of the artist, in accordance with Plato's theory of art, as surpassing the model of nature and, by improving on nature, to realize an ideal beauty in his works. We have already mentioned the role which this conception of the artist's task played in Western thought. It gave rise to the idea that the artist creates like God, that he is an *alter deus*. This idea finds its expression in biographies when the artist is elevated to the *divino artista*—in his heroization.

The opposite viewpoint, in contrast, appears to be entirely naïve; for this reason it has been called the layman's view or impressionist aesthetic. In this view the artist deserves praise for faithfully copying nature in his work. This viewpoint has also decisively influenced the image of the artist as it is outlined in biographies. To gain a better understanding of the conception on which this view is based, we start once again with a typical theme found in artists' biographies from classical antiquity right up to the present. In contrast to other typical motifs, however, the classical nucleus of this theme has been taken over unaltered in the biographies of later periods. No report in the literature on art is better known than the anecdote with which we start our survey.

This anecdote is to be found in Pliny (35:65) and was, as philological research clearly established, likewise borrowed from the work of Duris. The story goes like this: Zeuxis painted grapes; some sparrows flew by and pecked at the grapes. Parrhasios then asked Zeuxis to accompany him to his studio, where he would demonstrate that he could do something like it. In the studio, Zeuxis asked Parrhasios to pull back the curtain covering the picture. But the curtain was painted. Zeuxis acknowledged Parrhasios's superiority: "I took in the sparrows, but you took me in." [1]

It is almost impossible to estimate the frequency with which this anecdote and similar ones occur. We already meet it in antiquity in a number of variations: a stallion attempts to mount a mare painted by Appeles; quails fly at a picture on which Protogenes has painted a quail in the background; the painted picture of a snake silences the twittering of birds (Pliny, 35:95; 35:121; Strabo [14:652], cited in Overbeck, no. 1924). The majority of

1. Here one ought to mention the trompe l'oeil curtains which create the illusion of hiding part of the picture. They were in fashion in seventeenth-century Holland; see Reuterswärd (1956, 95–113) and Kennedy (1964, 168).

similar-sounding accounts that run through the later literature on art can be traced back to this or similar classical formulas. The story just told of Protogenes' picture is faithfully echoed in an anecdote served up by Aretino (1531, 1:xxviii). In this, the lamb carried by John the Baptist in a picture painted by Titian is supposed to have provoked joyful bleating in a mother ewe.[2] In 1508 Scheurl reports that a portrait by Dürer was mistaken by a dog for his master; a similar account in Leonardo's *Treatise on Painting* has been assumed to be the source of this report, but it actually goes back much further because the *Greek Anthology* (9:604) already describes the same incident (Panofsky, 1924, 90).[3] Ever since that time the lifelikeness of portraits has remained a favorite motif, and the large number of similar stories devoted to this theme in the Renaissance can be seen to derive from this idea: Titian painted a portrait of Pope Paul III which he stood in a window to dry; people passing by paid homage to the painting, mistaking it for the Pope himself (Vasari, 8:294; Hartmann, 1917, 48); something similar happened to Rembrandt's painting of his maid (Piles, 1715, 425). Philip II of Spain is supposed to have taken Titian's portrait of his father for the man himself; and a cardinal handed a pen and ink to Raphael's portrait of Leo X to get his signature (Zuccaro, 1607, 99).

Another cherished topic of many similar anecdotes was the marvelous effect of *quadratura*, or painted architecture. Yet here too the various reports connected with the works of Mantegna,

2. A horse painted by Bramantino was so lifelike that another horse attacked it (Vasari, 2:493); birds attempted to perch on the lilies painted by Murillo in his *St. Anthony of Padua* in Seville Cathedral. One could go on reciting such stories indefinitely; one from Victorian England will have to stand in for the rest. In her diary Effie Millais (1:324) speaks of the strange effect that one of her husband's pictures had: "When the picture of 'Spring Flowers' was on the easel out of doors and in bright sunlight, the bees used often to settle on the bunches of blossom, thinking them real flowers from which they might make honey."

3. An identical story was told of Sir Godfrey Kneller's portrait of his wife (Whitley, 1928, 21).

Georg Pencz, or Vredemann de Vries (Mander, 1906, 298–303)
—or those cited as proof that even in the Cinquecento grisailles
like those of Peruzzi were taken for genuine bas-reliefs (Zuccaro,
99)—all these stories can be traced back to a tale recorded by
Pliny (35:23) in which crows attempted to settle upon a painted
stage scenery.

The theme of the perfect imitation of nature is widely used in
descriptions of the young artist's precocious mastery of his craft.
Here a pupil paints an insect on one of his master's pictures, which
the latter before recognizing his error attempts to flick away.
Vasari (1:408) tells this story of Giotto, who was apprenticed to
Cimabue;[4] and the anecdote then migrates north of the Alps,
where Carel van Mander (198f.), for example, similarly connects
Hermann van der Mast with his teacher Frans Floris. (An identical
tale, but with Quentin Massys as Floris's gifted pupil, is to be
found in Kinkel's collection of stories [233].) Analogous stories
of Beccafumi's youth from the traditional oral accounts of Sienese
guides were set down in writing only in the nineteenth century
(Floerke, 313). Nor are such episodes confined to biographies;
comparable features are cited again and again as hallmarks of
great artistic accomplishments.

The theme of the painted insect that deceives its beholder,
used in this and many other anecdotes, is closely connected with
the studio practice of painting flies on pictures, a practice that
was prevalent among Dutch and German painters at least from
the beginning of the fifteenth century on (for example, see
Weixlgärtner, 1928).[5] The realism of this exercise may have lent
color to the motif of this anecdote.

 4. Actually it can already be found in Filarete's *Trattato* (665).

 5. Further examples are discussed by Panofsky (1953, 489) and Pigler
in *La mouche peinte* (1957, 47–64). This pictorial joke is often found in
illuminated manuscripts, e.g., in a Milanese one from the late fifteenth
century (*Accademie e Biblioteche d'Italia*, 14:147, 1940), and occasionally
even on sculpture (Bode and Volbach, 1918, 114). The Armenian book
illuminator Sargis Pidzak ("Bumblebee") is said to have received his
nickname when he painted a bumblebee which onlookers wanted to
chase away (Der Nersessian, 1936, 137).

There is no need to adduce any further examples; the immense number of works that could be cited contain no new elements. The same is true of Chinese anecdotes on this theme, of which there are just as many as Western ones. Even the motifs are identical—painted animals attract living ones and are taken for real by human beings. This identity, which can be pursued in the examples given by Herbert Giles (1905), extends to the most intimate details; Asian sources also speak of the painted fly which the art connoisseur tries to chase away (Hirth, 1900, 422).[6]

The most obvious explanation of these anecdotes must be that they were intended to emphasize the naturalistic qualities of an artistic achievement. This accords well with the fact that the anecdote was often reported in an abbreviated form, and thus became a formula for aesthetic judgments.

An example of this kind can already be found in Pliny (35:155), who quotes Varro: "It was impossible to tell the apples and grapes that Possis painted from real ones." In the *Decameron* (day 6, nov. 5), Boccaccio uses almost exactly the same words to define Giotto's art: ". . . so that not infrequently people's sense of sight was misled by the things that he created into mistaking the painted for the real." Here, as Rumohr (1920, 256) noted, one will scarcely fail to recognize the overtones of the motif that is reminiscent of fables about artists, but the formulalike character of the judgment is also rooted in medieval tradition. If, for example, we learn from Hugdietrich that works of art are "as if they had life," or from Wigalois that one is "just as like as if it were alive," such statements made by early German minstrels have exactly the same meaning (Ilg, 1881, 14). It would clearly be wrong to

6. For a Japanese example, see Feddersen (1925, 30). There is also the Indian king who broke his fingernails in attempting to pick up a peacock feather painted on the floor (Coomaraswamy, 1920, 27).

draw any conclusions from this piece of information about the
character of medieval works of art. It has long been recognized
that these and innumerable other such comparisons are fixed
formulas which are invariably used in describing a work of art;
they form part of the repertoire of ἔκφραοις, the rhetorical
description of pictures.

We believe that the same interpretation can be applied to
the relationship between the anecdotes and the classical as
well as the Renaissance work of art to which they refer.
Nothing that we know about painting in Hellenistic times or
about the art of later periods—from Giotto to Rembrandt,
to stay within the era from which our examples are taken—
substantiates the assertions of these stories. These anecdotes
too must be regarded as stereotyped formulas designed to
put a work of art in an especially favorable light. The degree
to which the imitation of nature has been perfected is not
stated directly but is implied. The anecdote tells us that the
artist's product is mistaken for reality, that the portrait is
taken for what it portrays. The question that we must there-
fore ask is: why was this particular form chosen; why was
such confusion between reality and illusion at the very
center of the anecdotes?

Before attempting to answer this question, we must
consider a further group of anecdotes with the same under-
lying motif. They originated in classical antiquity, and are
of special interest because of the artist with whose works
they deal—Daedalus, the mythical progenitor of Greek art.

In Apollodorus (2:6.3; cited in Overbeck, no. 102) the
following tale appears. One night Hercules is so deceived by
the lifelikeness of Daedalus's statue of himself that he throws a
stone at it. In one of Euripides' satyr plays an old man, scared out
of his wits by the appearance of Hercules, is talked into believing

that it was not Hercules but Daedalus's statue of him that he saw (Robert's entry in Pauly, 4, col. 2003). Another work by Euripides, a drama dealing with the Daedalus saga, is the source of the story that the sculptor made a wooden cow for Pasiphaë in Crete to enable her to satisfy her craving for the bull sent by Poseidon (Pauly, 4, col. 2001).

The form in which these stories have been handed down so closely resembles that of more recent ones, which are scattered throughout biographies of artists, that there can be little doubt about their intimate connection. One is led to assume that the widespread accounts of the public being taken in have their origin in the Daedalus stories cited above. The question concerning the relationship between the two groups of anecdotes gains in significance once we embark on the interpretation of the fables about Daedalus's works. These legends are easily identified as reinterpretations of mythological themes. Originally, possibly as early as the sixth century B.C., Daedalus was regarded as the creator of works which were endowed not just with movement, but even with speech (Robert's entry in Pauly, 4, col. 2002). It is probable that this tradition originated in even more ancient times.

The Athenians already interpreted these reports in several ways. According to an explanation given by the comedian Philippus, which was recorded by Democritus and Aristotle (*De anima*, 1 : 3 ; cited in Overbeck, no. 118), the mobility ascribed to Daedalus's statue of Aphrodite was produced by the artist's filling it with mercury. "Later, an equally rationalistic, but seriously intended, explanation held that Daedalus was the first to make his statues with feet apart, arms hanging loose, and open eyes" (Robert, in Pauly, 4, col. 2002). Yet these attempts at a rationalistic explanation coexisted with the continuing belief that Daedalus's works

had to be fastened down, to prevent them from walking away (Plato, *Meno*, 97D).

The idea that the artist creates statues that are capable of moving mechanically has a long and venerable history. Daedalus was not the only mythical artist to whom the Greeks ascribed these powers. Homer's Hephaestus was already capable of making mobile figures. He forged not only trinkets and weapons for the gods, but also tripods on golden wheels,

> on which (a sight
> Marvellous!) into council they should roll
> Self-moved, and to his house, self-moved, return.
> *Iliad*, 18:376f., tr. William Cowper

He made the gold and silver mastiffs (which Odysseus saw when he followed Nausicaa to Phaeacia), "guardians of Alcinoüs gate/For ever, unobnoxious to decay" (*Odyssey*, 7:94), as well as the figures that Hephaestus leaned against when he encountered Thetis:

> he took in hand
> His sturdy staff, and shuffled through the door.
> Beside the King of fire two golden forms
> Majestic moved, that served him in the place
> Of handmaids; young they seemed and seemed alive
> Nor want they intellect, or speech, or force,
> Or prompt dexterity by the Gods inspired.
> These his supporters were, and at his side
> Attended diligent. . . .
> *Iliad*, 18:416–21

Once we perceive that "the Attic Daedalus was clearly . . . the double of the craftsman-god Hephaestus" (Robert

in Pauly, 4, col. 1335), we gain the impression that the ability to create beings capable of motion and reason was the prerogative of the mythical artist, at least in the Greek world. But this idea frequently occurs in Indo-Germanic mythology; the Finnish smith god Ilmarinen also created a golden woman of exceptional beauty (Mannhardt, 1875, 322); and the Lithuanian angels of the art of smithery, Ugniedokas and Ugniegawas, also wrought a living virgin of gold (Veckenstedt, 1883, 34). Reverberations of the theme of a woman created by a mythical artist can still be discerned in the legends of Pygmalion and of the creation of Pandora (Robert, 1914, 17).

Viewed in this context, the anecdote about the deceptive power of works of art, which we found at the beginning of Greek biographies of artists, assumes fresh significance. The gift of creating the illusion of reality, for which it exalts the artist, can be compared to a gift that is the distinguishing mark of the mythical artist—his capability of creating beings that can move, even if only as automatons. This connection will become clearer if we pursue the legend of the deceptive power of the work of art through its subsequent migrations. A remote variation of this theme is particularly striking; it comes from Central Asia and the Far East, and we give here its Tocharian form (Chavannes, 1910–11, 2:12; Sieg, 1919–20, 362):[7]

A painter was staying as a guest in the house of a mechanic. The latter placed the figure of a girl beside the bed. The painter amorously grasped its hand, whereupon the apparatus fell apart.

7. There exist two additional translations of this story; see Sieg (1944, 8–13) and Lane (1947, 41–45); see also the remarks on other versions by Cuvreux (1960).

Deeply upset, the painter groaned, "Surely the master mechanic has been making fun of me over—alas!—the compelling power of passion, and over—alas!—the weakness of the intellect; to think that a man can make such vigorous love to a few pieces of wood! But this master mechanic also wanted to give me a demonstration of his skill in his craft; why shouldn't I do the same for him?" So he painted a picture of himself on the wall, with a rope around his neck and dangling from a beam, as if he had hanged himself. The next morning the mechanic believed that the painter had committed suicide, and fetched an axe to cut the rope. The painter then stepped forward, and the mechanic realized that he had been taken in by the picture: "The painting is one thing, and the painter is another."

While so far we have examined variations in which the classical theme has been preserved and merely adapted to the changing outlook of different times, it would appear at first sight that in this Asian version we not only are dealing with an adaptation to a different milieu, but are also introduced to a new idea—the juxtaposition of mechanical and artistic creation. The vague outlines of a hypothesis suggest themselves: we recall that the hidden meaning of the motifs wandering through the fantasy life of mankind sometimes became recognizable only gradually and in one of their later modifications, as if part of their ancient or original meaning had to be discovered anew, or at least unexpectedly revealed, after having been shrouded by innumerable distortions. The fact that the legend of the deceptive power of a work of art could undergo such a major transformation might then serve as evidence that here, as in other anecdotes, mythological beliefs lived on, "enabling" the legendary motif to satisfy the fantasy of man, no matter what the place or period. The Tocharian form of this anecdote merits

special consideration, because it can be linked to more ancient motifs that in their familiar version had already been distorted and worked over. The mythical artist's ability to create mobile figures, as was recorded of Hephaestus and Daedalus and many others, was soon explained rationalistically—and this part of our argument rests on solid evidence. Motion and life, which in mythology had a literal meaning, became pale metaphors, and the simile, "So true to nature that the work of art creates the illusion of life and movement," was retained in the legend. But in the migrations that this tale underwent its original significance was partially rediscovered, so that the mechanic of the Tocharian story is closer to the mythical artist, to Hephaestus of the *Iliad*, than to Zeuxis; for like Hephaestus, he creates figures capable of mechanical motion.

The Image as Magic The insight we have gained
 into the significance of the anecdote dealing with the deceptive power of the work of art was a result of examining its historical derivation. We believe that we can discern in it echoes of what was told of the mythical artist, that he could create life and motion. But this insight is still incomplete. To supplement it we draw on other reports dealing with the same phenomenon. These tell of works of art that were taken for living beings, and permit us to draw conclusions about the conditions determining this confusion—it occurs under the influence of some powerful emotions. Reports that the sight of a statue provoked desire, or that a punishment intended for a person was carried out on his effigy, presuppose that the work of art was considered to be alive.

The most famous of these reports deal with sensual love for a work of art. Of the numerous instances recorded in antiquity, several relate to two works by Praxiteles: his Cnidian Aphrodite and his Eros at Parion (Overbeck, nos. 1227ff. and 1263). Such tales already were collected in antiquity, for example, by Aelian and Athenaeus, and Athenian comedy early adopted the theme of the lovelorn youth who shut himself up with the portrait of his beloved (Birt, 1902, 40). One can include in the same category the legend of the Cypriot king Pygmalion, who in Ovid's version (*Metamorphoses*, 10:243ff.) becomes the creator of the object of his love (Roscher, 3, col. 3318). Another variant of the same legend occurs in one of the stories of the Persian Book of Parrots, in which four men share in the creation of a work of art which by their prayer gains life, ultimately compelling all four to fall in love with it (see R. Schmidt, 149ff.;[8] see also Leyen, 1917, 123).

Similar stories are scattered through the more modern art literature as well. It is said that a Spaniard was overcome by lust aroused by the irresistibly enticing—then undraped—figure of Justice on Guglielmo della Porta's tomb for Paul III in St. Peter's (Liebrecht [1879, 139], who gives additional examples). These stories have also penetrated the Islamic world. The figure of a female cupbearer, supposedly Shîrîn, the mistress of King Abarwiz, in the Grotto of Tâq i Bustân inflamed a man's passion; and in order to prevent this from happening again, the figure's nose was struck off (Schwarz, 1921, 4:488). This story is noteworthy in two respects: the statue was believed to be alive not only by the man who offered his love to it but also by those who mutilated it to prevent others from falling in love with it. The latter, moreover, take their revenge not on the statue but on the seductive woman it depicts.

8. Regrettably, this is one of the stories that has been omitted as "unsuitable" from the only English translation of *Sukasaptati* by B. Hale Wortham.

Here we come upon the most common practice associated with the equation of picture and depicted, namely, the belief in magic, especially effigy magic—the belief that "a man's soul resides in his image, that those who possess this image also hold power over that person, and that all the pain inflicted on the image must be felt by the person it represents." One also encounters the converse of this idea—that the harm done to a person must also be visible in his portrait. In this form the belief in the magic of the image dominates Oscar Wilde's *Portrait of Dorian Gray*.

There is scarcely any need to illustrate the universal diffusion of this belief by examples; it is enough to point out that the Quattrocento Italians who scratched away the Jews depicted in Castagno's fresco of the Flagellation, "in revenge for the injustice done to Our Saviour" (Vasari, 2:673), were acting no differently than the country folk of our own day, who have to be restrained from disfiguring the executioner in the Passion tableauxs. For it is in the sphere of religion that belief in the identity of portrait and portrayed is most firmly rooted. All belief in the miraculous doings of ritual images begins here. In some instances it is even possible to establish bridges leading from the practice of effigy magic to the practice of art—not only among primitive peoples but also in the art of postmedieval Europe. In the Renaissance wax and bronze statues were produced for the purpose of magic (as was amply documented by Warburg, 1932, 1:341). This idea occasionally also made its way into the biographies of artists.

Ku K'ai-chih (turn of the fourth century A.D.), the author of the famous picture-scroll in the British Museum, painted a portrait of a girl who had rebuffed him and fixed it on a wall with thorns, one of which pierced her heart, whereupon she

immediately fell ill of a pain in the heart. She recovered only
when the thorn was removed from the painting (Giles, 1905,
18).[9]

The belief in the identity of portrait and portrayed—
which the French philosopher Charles Lalo cleverly termed
the first aesthetic theory of mankind—not only seems to
be associated with the origin of representational art, but
also governed the formation of legends concerned with
the beginning of art. Two types of motifs can be distinguished
here.

Originally, lines were drawn around a person's shadow; this
was the beginning of painting as conceived in antiquity (Pliny,
35:15).

Another classical legend accounts for the origin of sculpture
in the same way (Pliny, 35:131; Athenagoras, cited in Overbeck,
no. 261; the source material is discussed by Robert, 1886, 131).[10]
The daughter of Boutades, the Sicyonian potter, painted by
lamplight the outline of the shadow cast on a wall by her departing
beloved. Her father filled the outline with clay, fired the ter-
racotta relief he had obtained, and thus produced the first piece
of sculpture.

The idea of the shadow as a potential picture only awaiting
someone to fix it recurs in Tibetan and Mongolian legends about
the origin of the Buddha image. Several artists tried to paint
Buddha's portrait, but their art failed them, so Buddha had his
shadow traced and filled in with color (Laufer, 1913, 37n.;
Cohn, 1925, xxxi).[11]

9. See also Ch'en Shih-Hsiang's comments on Ku K'ai-chih (1948).
Other examples of such magical practices recorded in the Chinese
literature are quoted by Eberhard (1941, 107).

10. This legend has often been depicted in paintings of modern times,
especially of the eighteenth century when silhouettes were in fashion;
see Rosenblum (1957), Levitine (1958), Wille (1960).

11. See also Hackin (1913). See Soper (1949–50) on the "Cave of the
Shadow" near Hadda, where Buddha is said to have left his shadow.

In these stories the image is a substitute for the person portrayed—whom it reproduces mechanically. The shadow whose outline is traced is deemed to be a part of the person himself. This idea is reminiscent of a common notion of magical thought, according to which possession of a part of, or the parings from, a person's body lend one power over him.

The second type of legend about the origins of art is based on the belief that the image is a replacement of the dead person.

We start with the Indian legend of the origin of painting as recorded in the *Citralakshana*, which is preserved only in the Tibetan Tanjur (see Laufer, 1913, 129–36).[12] Long ago, when men did not yet die before their time, a Brahmin came weeping to a holy king and complained that his son had been prematurely taken from him. The king addressed Yama, the god of death, who however refused to relinquish the Brahmin's son. Thereupon Brahma himself appeared and commanded the king, "True to his form and with the aid of colors, thou shalt paint the Brahmin's son, so that it is like unto him." The king painted the boy, and in this guise Brahma restored him to life and gave him to the Brahmin alive. This idea is also found in classical and Judaeo-Hellenistic legends (Fulgentius, 1:29; *Wisdom of Solomon* [see McCown, chap. 14, v. 15]),[13] and in Euripides' story of Admetus who wanted to have a marble statue of his dead Alcestis made so that he could embrace it instead of her, as though it were alive;[14] or Vasari's account (3:691) of Signorelli painting the

12. See also Zimmer (1955, 383). Marco Polo reported the following legend from Ceylon: after the Buddha's death his father, the king, had a golden image of the son made, and that was the first idol (409).

13. Stummer (1944) assembled several passages from the pagan and early Christian literature in which the portrait of the dead is regarded as the origin of cult images.

14. In China we find among the twenty-four paragons of filial piety Ting Lan, who carved an image of his deceased mother and worshiped it (Mayers, 1874, 219, no. 670).

corpse of his son, "so as, by the agency of his hands, to have as
often as he wanted before his eyes one whom nature had given,
and an inimical fate had snatched away."[15] (The theme of the
painter who paints a picture of his dead child is movingly ex-
pressed in Theodor Storm's short novel, *Aquis submersus*.)

The Indian story is, according to its interpreter (Laufer),
still dominated by the idea that the picture is designed not
merely to keep alive the memory of the dead, but "to be
the substitute for the dead and to incorporate his soul." In
later versions, namely, Vasari's, the picture serves only the
function of aiding recall. Such remembrance, however, we
may conclude, received meaning and life from the belief
in the identity of picture and depicted—a belief that, though
faint, continues to live on in the unconscious of men. Its
effects extend into our own times. When revolutionaries
rip up effigies of toppled rulers, or political groups burn
portraits of the opponents' leader, or even when lovers
destroy the picture of an unfaithful beloved, the same belief
is at work. While persons engaged in such actions are not
consciously aware of this belief, it nevertheless is a potent
force stemming from the deeper layers of the psyche.

The problem of what gives rise to magical thinking, and
the meaning of effigy magic in particular, has frequently
been discussed from a number of angles. We summarize
in as general terms as possible and rather cautiously what
can be gleaned from such diverse views: in certain circum-
stances men are inclined to equate, to a considerable extent,
the picture and the original it depicts. Such conditions are
more easily found among primitive people than among

15. "Tintoretto painting his dead daughter" is the subject of a once
very famous painting by Leon Cogniet; see Rosenfeld (1935), Pigler
(1957, 1), Haskell (1971, 66, 78).

people who have reached our level of civilization, though in our culture they do occur in the wake of mental illness or in situations that are charged with intense emotions; they evolve more readily in crowds than in an individual; they occur more frequently in children than in adults, though here, too, strong affects make them easier to observe.

From all these various empirical observations, we may draw one conclusion which may again be stated in schematical formulation: the "stronger" the belief in the magic function of the image, in the identity of picture and depicted, the less important is the nature of that image. To take a simple, if not entirely equivalent, example: in a certain phase in the development of children's play, the child has little interest in the intrinsic properties of a toy. The effects of imagination are so great, that a stick becomes a hobbyhorse, a box is turned into a ship, or a broom into a gun. On the basis of this empirical finding we can gain a better understanding of the far more difficult-to-interpret phenomena of primitive and folk art. In general terms again: whenever a high degree of magic power is attributed to an object —whether this be the fetish of primitive men or the miracleworking ritual image of civilized man—its resemblance to nature is rarely of decisive importance.

We resist the temptation of discussing individual examples from this fascinating field of inquiry; instead, we return to our main topic by way of inserting a particularly fruitful idea that Heinrich Gomperz (1905) developed in a neglected study. Where the belief in the identity of picture and depicted is in decline, a new bond makes its appearance to link the two—namely, similarity or likeness. Formulating these remarks differently, we would say: the closer the symbol (picture) stands to what is symbolized (depicted), the less

is the outward resemblance; the further apart, the greater
is the resemblance. This thought advances our understanding
of the anecdote that we placed at the beginning of this
section—for it is due to the picture's lifelikeness that it is
confused with what it depicted; the two resemble each other;
they can substitute for each other.

We begin to appreciate the significance of the artist's
accomplishment if we adopt the hypothesis that a different
and earlier view of the world accepted the equation of
picture and depicted without recourse to the bond of "like-
ness" or "similarity."

We should, however, make it clear what we mean by likeness.
It has nothing to do with the idea of "true to nature," which
has the aim of exact photographic reproduction; rather it may
be more generally described as the attempt to bring pictorial
conventions to life. This attempt occurs as the result of historical
development in a process that aims at accurately locating repre-
sentations in time and space. Keeping in mind this restriction of
the term (which we shall not attempt to justify), we unavoidably
are forced to resort again to such terms as "true to nature" and
"naturalism" as they are commonly used in ordinary language.

The hypothesis proposed above can to some extent be
supported by historical material. For the battle against the
theory and practice of effigy magic runs through the history
of Greek philosophy, from its classical heyday right down
to the days of the Roman Empire.

The "ban on images" in classical antiquity and in the Jewish
tradition was based on similar premises (Geffcken, 1916–19).
The proponents of the view that the gods were spiritual beings
maintained that anyone who took an image of a god for the god
himself misconceived the true nature of both gods and heroes
(Heraclitus, *fragm.* 5). Pausanias (3:xv, 11) made a direct attack

on the practice of effigy magic itself when, in referring to the wooden statue of Aphrodite at Morpho in Sparta, he asked "why Tyndaros bound this statue with chains and he completely rejected the idea that Tyndaros wanted to punish Aphrodite for the shame she brought upon his daughter, because Tyndaros would not have been so simple as to believe that by making a statue out of cedarwood and calling it Aphrodite, he could harm the goddess by wronging her image" (Robert, 1909, 34ff.).

In further developing our hypothesis, we arrive at the following, purely schematic, construction. At the dawn of Greek art, when the belief in the identity of picture and depicted was prevalent, there was little or no concern with making the work of art as lifelike as possible; in subsequent eras when this belief was on the wane, naturalism was regarded as a distinct accomplishment of the artist. This then provides us with a clue why the anecdote about the deceptive power of a work of art is found among the very earliest reports about painters and sculptors—the information in fact comes from the Hellenistic period. The artist's handiwork closes the gap separating picture and depicted. At the same time, however, the anecdote contains elements of the accounts in which the mythical artist is described as the creator of enlivened things.

This sequence of historical evidence can be further expanded. The new theory of art of the Middle Ages revived the never entirely relinquished belief in the magic identity of picture and depicted. When St. Augustine (citing Apuleius) reiterates the view of the much-quoted Egyptian Hermes that the demonic arts have the power "to install invisible spirits in visible objects formed of matter," he is in fact referring to the secret bond between art and theurgy. It is as though works of art were regarded as the bodies of the

pagan gods when he says, "Surely, there reside in these images specially invited spirits that are not without the power either to do harm, or to gratify some wishes of those who grant them divine honors" (Borinski, 1914, 1:15).[16] Thus in this declaration of St. Augustine's we rediscover a profession of the belief in the magical qualities of images. This belief permeated the conceptions of early Christianity, and was clearly expressed in such apocryphal accounts as that which describes the collapse of the heathen idols on the holy family's Flight into Egypt. It also determined the attitude of the early Middle Ages to a large part of the artistic legacy of antiquity.

The reproduction of spatial dimensions became alien to the artistic language of subsequent periods that were bent on reinterpreting all remnants of plasticity into two-dimensional projections, thereby gradually foregoing the spatial and temporal characterization of the individuality of the depicted. In this later period the classical figure in the round, "which already had an aura of darkness and demonic magic in late antiquity," must have seemed the very embodiment of the devil's handiwork of deception. (We can obtain some sense of this attitude by imagining the feeling we experience when a lifeless object unexpectedly shows signs of life: this uncanny feeling is linked up with automatons.)

The attitude just described governed the reactions to classical art in the Middle Ages. It is most apparent in the guidebooks to the cities of Rome and Constantinople, which sought to interest the pilgrim, who was no longer traveling to the seats of Empire but journeyed to the hearths of eternal salvation, in the remnants of a glorious past. How

16. Cult images with the magic power of movement are discussed by Bielefeld (1953–54, 110).

long it survived as a superstition and continued to dog the thinking of even the later Middle Ages can be seen from an account transmitted by Ghiberti (1:63). In the fourteenth century, at a time when classical art was openly and proudly imitated and classical sculpture was already being collected in northern Italy, an ancient statue of Venus was found in Siena. Though at first prized, as soon as a calamity struck the city, it was broken up as the bringer of misfortune, and its shattered pieces were buried in enemy territory.

By this time the artist had as good as disappeared from the scene and even names known from surviving records occasionally appeared under a new guise. The *Mirabilia Urbis Romae*, the best-known medieval guidebook, wove the names of Phidias and Praxiteles, which could still be read on the plinth of the statues of the horse trainers on the Quirinal, into a fable:

During the reign of the Emperor Tiberius there came to Rome two young philosophers called Praxiteles and Pitias. They claimed to have such wisdom that they were prepared to repeat word for word anything that the Emperor might say while they were out of the room. They were as good as their word, but refused any payment, asking instead for perpetual commemoration as philosophers by two marble horses stamping the ground with their hooves, signifying the princes of this world. That they were then placed beside these horses as nude figures with raised arms and outstretched fingers indicated their ability to tell the future, their nudity signifying that knowledge of the world was laid bare in their souls (Kinkel, 1876, 173).

Just as the work of art is here reinterpreted in symbolic terms, so the artist became a soothsayer. Just as the sculptors who were regarded as miracle-working philosophers, so Virgil in the Middle Ages was regarded as a magician and

a whole series of legends was woven around him. But old legends ascribe to the magician Virgil the ability to make automatons. There are similar reports about Albertus Magnus, who, "under a favorable conjunction of the planets," cast a metal statue endowed with the power of speech—which was then destroyed as a pagan idol by a monk (Floerke, 1913, 230). Universal abilities also seem to have been attributed to the medieval artist at times when he appeared in the contemporary literature.

In this context we still must add that the anecdote about the deceptive power of the work of art underwent a reinterpretation in antiquity itself:

> Zeuxis is said to have raised the question why the birds pecked away at the picture of the grapes which a boy was carrying and why the picture of the boy did not frighten them away. Two different explanations were proposed. One, found in Pliny (35:64), suggested that the boy was "not so well" painted as the grapes; the other, by Seneca (10:34, 27), maintained that this very incident showed that as an idealized portrait the painting of the boy was superior to that of the grapes (Overbeck, no. 1649).

Here we are confronted with the contrast between reality and beauty which especially preoccupied the Romans, and which received its most succinct formulation by Quintilian who said that Demetrios, the fourth-century Athenian portraitist, preferred beauty to likeness (cited in Overbeck, no. 903).

The same attitude is also to be found in Strabo. He tells the story of Protogenes, who discovered that people's attention was being drawn away from the main subject of one of his pictures by the detail of a quail, whose lifelikeness was such as to have

attracted real quails. Annoyed at this, he blotted out the bird (Overbeck, no. 1924).

In this story the meaning of the anecdote about the deceived onlooker is reversed. The old contrast between the inventive and the imitative function of the visual arts, which we have traced back to the very earliest pronouncements about works of art in the literature, and which ultimately derived from Plato's philosophy, thus finds expression in contrasting interpretations of this anecdote.

There is little doubt about which of the two standpoints prevailed at the close of the classical era. The view adopted by early Christianity was unequivocally stated by St. Clement of Alexandria: art is praiseworthy only when it does not deceive people to take it for reality (Borinski, 1914, 3).

As recorded in numerous anecdotes, Chinese tradition had a fundamentally different view of the relationship between picture and depicted, between illusion and reality. We hear again and again that animals or people left their places in their pictures and wandered into the world and that every harm they experienced in their wanderings was subsequently visible in their pictures. Instead of illustrating this conception by citing other examples, we select one that was widely disseminated and that sheds light on the attitude of the artist to his work. It tells us that the painter avoided putting eyes in his portrait to prevent it from coming wholly to life (Hirth, 1905, 424; 1900, 16f.; Fischer, 1912, 21).[17] The idea that the artist would thereby retain control over his creation—by denying it full vitality, as it were—is rooted in magical beliefs. The image of the artist who bestows

17. Eberhard (1941, 203) records the story that dragons flew away as soon as the artist inserted their eyes in a picture of them.

life, who enlivens his pictorial works by his labors, on the
other hand, leads back to the belief in the creative power
of the deity that breathes life into forms of clay.

The Envy of the Gods Mythology credits the artist
 with two types of achievement
—that he forms beings, and that he erects buildings that
reach into the sky or that rival the dwellings of the gods in
size and grandeur. Both of these activities infringe upon
the prerogative of the gods, both provoke punishment.
The story of the Tower of Babel is the best known example
of man's overweening ambition and divine retribution:
"Go to, let us build us a city and a tower, whose top may
reach unto heaven" (Genesis, 11:4).

This story has come down to us in several versions. The lapidary
brevity of the biblical account was later embellished in the
Jewish Haggadah (Jeremias, 1930, 190). It is noteworthy that an
identical story emerged in Mexico in connection with the
building of one of the stepped temple towers whose architectural
relatedness to the Babylonian ziggurat (of which the Tower of
Babel was but one famous example) remains an unresolved riddle
(Jeremias, 1930, 194; Las Casas, 1919).[18] In addition to these
stories of colossal towers, there are accounts of cyclopean walls
built by giants. According to several versions, the Tower of
Babel too was built by giants (Jeremias, 1930, 193; Schnabel,
1923, 68).

Closely associated with the same range of ideas is another
belief which persisted throughout the centuries all over the

18. This casts some doubts on the assumption that the widespread
"Tower of Babel" type stories ultimately go back to the biblical narrative.
For an example from the Congo, see Bittremieux (1926, 799); for an
Asiatic one, see Nebesky-Wojkowitz (1953, 889f.).

world: every building is an affront to the deity who must therefore be appeased by a sacrifice. This belief was formulated in the most general terms by Friedrich von der Leyen (1917): "Great buildings are regarded as sacrileges, as in the Jewish story of the Tower of Babel; only demonic powers —or in German legends, the Devil himself—can bring them to completion. Injustice, betrayal, and trickery are gruesomely associated with their construction. One only has to think of the ancient Greek tale of Laomedon and the building of Troy, or of the Scandinavian saga of the giant builder. Every building requires a human sacrifice, and threatens to bring misfortune or terror if these sacrifices are not performed" (77). There is no need here to describe the gradual substitution of symbolic gifts for human victims, but we would like to suggest that this primeval custom lives on in the numerous later stories of architects who end their lives upon the completion of their works.

The belief in the "envy of the gods" survived into modern times as a figure of speech and could, for instance, be read in the inscription on Giulio Romano's tomb which Vasari (5:557) recorded. "Enraged that a mortal should breathe life into his creatures, and that the buildings of a mortal should rival those of heaven, Jupiter snatched this artist from the earth." [19] Here the sacrilege of the architect and that of the graphic artist stand side by side. His ancestor is the Greek Prometheus, who overstepped his bounds by instilling breath into his sculptures.

Fulgentius (2:79) relates the story as follows. Prometheus formed men from clay, but he was not able to breathe life into

19. This was removed from the second edition. See also Vasari (2:365) on Brunelleschi's Cupola in Florence: "It seems that Heaven's envy manifests itself in the lightning which strikes it continually."

them. When he succeeded, with Minerva's help, in stealing the divine fire from heaven, he was also able to instill a soul into his creatures. (In the ancient view of the Greeks, man was composed of earth and fire [Plato, *Protagoras*, 320D].) But Prometheus was punished for his presumption: he was bound to the Caucasus, doomed to have his liver perpetually gnawed by a vulture.

The figure of the fire-bringing Prometheus is closely associated with that of another mythical artist, the fire-demon Hephaestus, whose cult soon displaced that of Prometheus. Just as Prometheus was bound to the rocks, so Hephaestus, the creator of human figures endowed with mobility, was struck lame. The hypothesis which we offer seeks to establish a common element in their fate. The story of a third figure belongs here as well—that of the Titan Epimetheus, who made a human figure out of clay, for which piece of imitative aping Jupiter turned him into an ape, and banished him to the Pithecusan islands.

This story is to be found in Boccaccio's *Genealogia Deorum* (4:42), but it goes back to an unidentified Greek source (possibly Suidas on Kerkopes; see Habich, 1920, 12). The transformation into apes also occurs in Talmudic versions of the Tower of Babel story, in which its builders were changed into "apes, ghosts, spirits, and demons" (Treatise Synhedrin, 109a; see Goldschmidt, 1897, 7:490). We can similarly understand the appellation "God's ape" which was used to characterize the artist in the Renaissance—from Villani to Shakespeare. Panofsky (1924, 89) has traced its derivation and history. A denigration in antiquity, it became a title conveying high praise in the Renaissance (Schlosser, 1927, 268), only to revert to its original disparaging meaning (see below, p. 98).

Here, in brief outline, we have the image of the denigrated artist punished for his presumptuousness, who is the counter-

part of the heroized artist. One must not, however, make the mistake of identifying the deed for which he pays by his punishment with that of making figures alone. Even though we may deduce from the fact of his punishment that originally there was a ban on images, which had the function of protecting the deity from the magic that might be practiced on its image, the ability to create images was only one element in the characterization of the mythological artist. The punishment that he suffers should be seen in a wider and more sublime context: it appears to be intimately linked with the symbolic significance of fire, as a sign of creative potency, and the harnessing of fire as one of the earliest cultural accomplishments in the history of mankind. The figure of the artist fuses with the more general and more numerous ones of those who defy the gods. This link is also determined by the symbolism associated with Daedalus and his Nordic counterpart, Wieland. By means of "secondary elaboration," the myths connected with these two blended contradictory elements in the narrative. Their activity as artists and their invention of wings, the mastery of the sky, and their capacity to fulfill one of mankind's dreams have all been pragmatically combined. The technique of flying which they devised had the purpose of freeing them from captivity.

The motifs of this myth are widely diffused. A Nike on a Sassanid relief in Tâq i Bustân was taken by the Arabs in the Middle Ages to be a self-portrait of the Greek artist Fattus, who had portrayed himself with wings (Schwarz, 1921, 4:488 [see also Ernst E. Herzfeld in *Der Islam*, 1922, 12:137]). An Iranian and a Rumanian story both tell of an architect who escaped from captivity with the aid of home-made wings (Schwarz, 1921, 5:455). In the Rumanian version, the flight fails, so that there

would seem to be some connection with Icarus's flying too close
to the sun. In both versions, however, the original reason for
the architect's imprisonment and impending execution was that
he had given an affirmative answer to his client's question whether
he could create something better than the building that he had
just completed. This motif, too—the client's envy of the artist's
accomplishments—is common property in the traditions and
occasionally occurs independently of the others, for instance,
in a Chinese anecdote (Giles, 1905, 206; see also Basset, 1906,
22; Spanish, Rumanian, African, and Russian parallels can be
found [in Mayer, 1956, 20; Sinninghe, 1943, no. 992; Talos,
1969, 196; Thompson, 1955–58, 5:311, 5:497]). And the monks
of Blaubeuren are supposed to have put out the eyes of Jörg
Syrlin the Younger after he had carved their choir stalls and
High Altar so that he could no longer create anything to rival
his masterpiece (Nagler, 1835–52).

Such connections between the mythical artist and the
broader mythological conceptions yield the insight that the
artist in myths is not a clearly circumscribed figure. It accords
with this insight that the Homeric artisan, the demiurge,
still belongs to a unitary world in which the practice of magic
included the pictorial and statuary arts. Art too is rooted in
the "mystic ideational residue" of "a sacrosanct primeval
profession that made no distinction between mantic magic,
and the subsequently differentiated crafts; . . . the mystic
aura that for so long hung about the practice of particular
crafts" stemmed from the same source (Eisler, 1910, 241).

The artist, however, seems never to have entirely lost
the belief in the envy of the gods. It emerged in the delusions
of a mentally ill sculptor of the eighteenth century, Franz
Xaver Messerschmidt, who felt persecuted by the Demon
of Proportion because of the perfection he had obtained in
his art. In view of all that is known about the mechanism

of paranoid delusions, we may assume that this delusion was based on a "projection"—that in fact the artist himself felt the "Promethean urge" to compete with the deity (Kris, 1933, 411 [1952, 127, 150]).

But the Greeks still heroized the denigrated and punished artist. In the myth itself one can discern the feeling of ambivalence that has always accompanied the great of this world. A residue of this ambivalence directed to the artist is also found in mythology in a different context.

The Telchines and the Idaean Dactyles—the latter related to the similarly demonic phallic dwarves and gnomes of Nordic tales—were skillful smiths; adept in handling fire, they can be related to the Demon of Fire, from which the figure of Hephaestus emerged, and also to the fire-bringer Prometheus (Overbeck, nos. 27–55; Roscher, 5, col. 236ff.; Pauly, 4, col. 2018; Kaibel, 1901, 488ff.).

Unlike the Nordic gnomes, however, they were also sculptors. The Telchines are supposed to have been the first to create images of the gods, and it is in this role that they make their appearance in Goethe's "Klassische Walpurginsnacht":

> We were the first, we were they,
> Who shaped gods like men, worthily.
> Wir ersten, wir waren's, die Göttergestalt
> Aufstellten in würdiger Menschengestalt.

In the same way the Dactyle Skelmis appears as a sculptor (Overbeck, no. 44; Kaibel, 503).

These Telchines and Dactyles are described as split characters: they are regarded as simultaneously good and evil, helpful and dangerous. Their magic powers are both admired and feared. It appears to us that these contrasting qualities can be linked with those of the exalted mythical artist. This was the first intimation of the dual role of the

artist as both evil magician and mighty creator. This con-
ception pervaded the Greeks' image of the artist and may
also have codetermined his social position and the low esteem
in which they held him.

This dual characterization of the artist, at once both
admirable and dangerous, regularly reappears in traditional
accounts and persists in actively shaping the attitudes of his
contemporaries to him. Even the vicissitudes of the artist's
life, which veer between Parnassus and Montemarte, between
heroization and denigration, might in part be understood
from this angle. We refer back to the apocryphal account
of Jesus' early childhood. The Gospel depicts him not merely
as the creator of life, as *deus artifex*, but also as a dangerous
magician. Just as he breathed life into clay birds, he also
had the power to take away the life of those who opposed
his will. Thus, in a popular syncretistic form, an ancient
pagan image of a deity whose powers are abitrary and
capricious found its way into the Judaeo-Christian concept
of God the Creator.

4

The Special Position of the Artist in Biography

His Virtuosity In the preceding chapters we
 have attempted to find the roots
from which several themes in artists' biographies grew.
In this final section we are concerned with a new problem:
the special position accorded to the artist by his contem-
poraries. Here too we shall have to confine ourselves to
presenting only a few typical biographical motifs. In view
of this restriction, the insight we can gain is of necessity
fragmentary and limited. For we shall have to exclude from
consideration all that pertains to the actual position of the
artist in society—what it was like in different historical
periods and how it evolved. On the other hand, we shall
encounter various basic attitudes in the interplay between
artist and his surroundings, so that we will be in a position
to demonstrate that these attitudes too are connected, though

often only loosely, with the notions described in the preceding sections.

The best way to gain an idea of what the artist's special position implies is to turn to our everyday experience and examine the attitudes with which we, as laymen, approach the artist's work. Initially we are amazed at the artist's ability to reproduce reality in a recognizable form, to make a "lifelike" portrayal of it.

Apelles used this ability to avenge himself upon an unknown person who had insulted him and who was identified by his portrait which the artist drew from memory (Pliny, 30:89).[1] Filippo Lippi owed his release from captivity with the Moors to the portrait he made of the chief corsair (Vasari, 2:614; Kurz, 1933); and according to a tradition handed down in Venetian guidebooks, Dürer, who had been condemned to death, owed his pardon to two wooden statues which he had artfully carved while he was in prison (Goethe [1932, 24] drawing on Keyssler [1760, 4:35]).

To gain a better understanding of this type of reaction to the artist's work, we start with an account by Carel van Mander (1906, 406) who describes the success achieved by Martin Fréminet at the French court. In the king's presence the artist began, "without drawing, to make a foot here, a hand there, and a face at another place, so that before long, to the king's great astonishment, there was the fine figure of a man." The technique used by Fréminet is well known to us, since it is still used by painters today—especially by street and fairground artists who work very rapidly—and

1. In the Renaissance, this story was transferred to Sodoma (Armenini, 1587, 27f.) and in the seventeenth century to Annibale Carracci (Bellori, 1672). A Scandinavian version is recorded by Panzer (1930, 126f.).

it never fails to have an effect. What is it based on? The fact that an artist begins with an insignificant detail, whose function in the whole becomes apparent only later, gives rise to the impression that with unerring certainty the painter puts down on the canvas a picture that he carries within him—and not a depiction of an exterior model.

The onlooker is inclined to ascribe to the painter the possession of that "internal figure" which, in Dürer's words, is the mark of the *divino artista*. The element of admiration evoked by this age-old artistic trick might then be rooted in the belief that the artist possesses a more profound knowledge of nature than the layman. In a somewhat modified form— as the belief that the artist is capable of envisaging the whole from a single part—this thought is the theme of a famous Greek anecdote, which Gerlach (1883) is inclined to regard as the subsequent embellishment of a proverbial saying [see Erasmus of Rotterdam, 308f.].

As Lucian tells it, Phidias was shown a lion's claw and thus was able to figure out how large the whole lion should be shown. He himself then made the famous utterance (which is better known in its Latin form): "ex ungue leonem" ["the lion from a toenail"] (Lucian, *Hermot.*, 54; see Overbeck, no. 799; see also Pauly, 25, col. 985). There are other versions of this anecdote, one of which is that Dürer was once brought a single limb of a crucified Christ; when he carved the rest of the body accordingly, its proportion exactly matched those of the original, which was again brought to light (Hampe, 1928).[2]

The superiority of the artist described in this anecdote ultimately is due to the fact that he has a knowledge of

2. For Indian parallels, see Schick (1934, 220) and Coomaraswamy (1931, 2:6).

proportion which is not accessible to the layman. Here a circle closes itself: for knowledge of proportions, so ardently striven for by the artists of antiquity and the Renaissance, meant knowledge of the secret set of laws in accordance with which God had created man.

The roots of this idea also reach back to the theory of art, as set down in, say, the legend of the two brothers, Telecles and Theodorus of Samos. Separated from one another, each worked on one half of a sacred image; when the two halves were put together, they fitted perfectly. The two brothers were enabled to do this by their mastery of the Egyptian theory of proportions which, unlike the Greek, did not rely on visual perception (*Diod. Sicul.*, 1:98; in Overbeck, no. 279). This explanation adopts the Platonic view of the superiority of "objective" Egyptian art over Greek, and takes us back to the basis of the capabilities of the *divino artista*.

Mastery of proportion takes its place alongside the artist's ability to design a picture of reality from within. Both serve to define his creative ability, and both form part of the distinguishing characteristics of the *divino artista*, whose mental superiority is still being admired today in the performance of the trick drawings referred to above.

The second element to which Fréminet owed his success has also been known since olden times. This is the layman's astonishment at the speed with which the artist operates. Biographies devote ample space to this theme as well.

Tintoretto brought a finished picture instead of a sketch for a competition (Piles, 1715, 263). To win a bet, Tiepolo, who "painted a picture in less time than it took someone else to grind his colors," did twelve Apostles half life-sized in ten hours (Monnier, 1928); and under the same conditions, Rembrandt

made an etching of Amsterdam in less than the time that it took his servant to bring mustard to the country property of the mayor Six, whence the title of *De la moutarde* became attached to the sheet (Nagler, 1835–52). Luca Giordano owed his fame and his nickname of "Fa Presto" to his rapidity, as did earlier artists, for example, Lorenzo Bicci (Vasari, 2:52). One could cite any number of similar examples. The speed with which the artist performs his task apparently creates the impression that the artist also has sovereign mastery over the world that he paints in his pictures. We glean something of the deep-rootedness of such convictions by a half-legendary account which asserts that the columns, pillars, and vaults of San Giovanni in Pisa were all made ready and raised in a fortnight (Vasari, 1:239). In this as in other traditional stories, it is impossible to mistake the echo of mytho-logical and legendary accounts that ascribe the artist's speed to the influence or assistance of supernatural powers.

Far Eastern anecdotes employ the same motif, but with a different emphasis. It is related of Hokusai that he dashed off the picture of a cock commissioned years earlier in a few minutes under the gaze of an impatient client, but then showed the out-raged man an entire roomful of sketches of all kinds of cocks. The fleeting work of a few minutes was in fact the fruit of years of grinding labor (Roessler, 1924, 7).[3] That speed is the result of practice and of special competence on the part of the master has also been maintained by Western artists, in exactly the same spirit as this story. Whistler upheld this viewpoint in court, in

3. "Kyosai sent a picture of a crow to an exhibition, fixing the price at 100 yen. When people made remarks about the exorbitant price, he replied that the sum was but a small fraction of the price of the fifty years of study that had enabled him to dash off the picture in this manner" (Anderson, 1899, 32). Much earlier a Spanish anecdote puts practically identical words into the mouth of Alonso Cano, who in the end destroyed his work because it had not been properly appreciated (Palomino, 1947, 992f.).

order to prevent one of his works from being evaluated by the amount of time he spent on it (Roessler, 1924, 19).

All this is the background against which another and broader dominion of biography develops and from which it occasionally even becomes detached—the artist's "virtuosity," which, as the mark of artistic attainment, plays a significant role. The attainment appears to be a value in its own rights; technique becomes an end in itself.

This attitude is most clearly expressed in the famous story describing the rivalry between Apelles and Protogenes. In Pliny's version (35:81ff.), Apelles visits Protogenes' house on Rhodes and, in his host's absence, draws an exquisitely fine line on a panel. Without making his presence known in any other way, he leaves it behind as a kind of visiting card. Protogenes recognizes the hand of Apelles, paints a second, even thinner line over that of Apelles, and hides when Apelles repeats his visit in the hope that he will witness Protogenes' discomfiture. Apelles, however, succeeds in painting a third line on top of the second one. Duris, who is credited with the invention of this tale (Sellers, 1896, lix), here pins the theme of the artists' rivalry (which will continue to preoccupy us) to the artist's most abstract accomplishment. In later times, repeated attempts were made to give this story different and more lively reinterpretations. Entirely in keeping with what the early Quattrocento deemed to be the most important artistic task, Lorenzo Ghiberti (1:24) proposed that one had to assume that it was problems of perspective in which Apelles and Protogenes were trying to outdo one another [see also van de Waal, 1967, 5–32]. Such reinterpretations, however, deprive the anecdote of its exemplary content—which is nothing other than sheer virtuosity.

A modern variation of the same theme is the story of Giotto who, to prove his mastery, drew a perfect circle freehand in the presence of an astonished papal emissary (Vasari, 1:383). This

feat too became linked with a proverbial pronouncement: "Tu sei più tondo che l'O di Giotto" ["You are sharper than Giotto"] (Wesselski [1929, 208], who cites further references). Not only was the same story transferred to Beccafumi (Floerke, 1913, 316) and Dürer (Hampe, 1928), but a similar anecdote was told of Wu Tao-tzŭ (Giles, 1905, 46).

The artist's virtuosity, a prominent mark of his distinction, is a theme that was subjected to a great variety of transformations. A special group of stories is concerned with the dimensions of the works of art.

Pliny (34:40) reports, on the one hand, that Lysippus's Colossus at Tarentum could be supported only by means of a special balancing technique, and, on the other, that some artists could work on a most minute scale. Theodorus cast a bronze statue of himself in which "he was holding in three fingers of his left hand a chariot-team so small, that it could be covered entirely by the wings of a fly which he made at the same time" (Pliny, 34:83). A similar story was told of Phidias (Overbeck, no. 776). Finally, the role played by minuscule sculpture in Mannerist aesthetics has often been discussed (see Vasari on Properzia dei Rossi, and Neudörfer on Flötner). Its love of carved plum and cherry stones survives in the collections of early art and curiosities.

The reports that attempt to highlight the artist's virtuosity belong, we believe, in the same category as those that tell us of the artist's ability to imitate exactly the work of others and thus to adopt any style he chooses.

In this context, one might mention Michelangelo selling his famous Cupid as an antique, or Pier Maria da Pescia burying his own works and arranging for them to be dug up before the eyes of Charles VIII when he made his entry into Rome (Panofsky, 1921–22, 56; Kris, 1929, 39). Later biographies contain just as many tales of copies and forgeries, e.g., Mignard's after Reni,

or Teniers's after Bassano and others, which earned him the
sobriquet of "ape of nature" (Nagler, 1835–52).

Once again we can do no more than touch upon an exten-
sive field and merely point to the existence of an area which
marginally has some bearing on the special role of artistic
ability.

What figures as manual dexterity in the case of the painter
or the sculptor becomes inventive ingenuity in the case of
the architect. The famous story known as "Columbus's
Egg" will serve to illustrate this aspect of biographical
characterization.

This story was in fact related of Columbus rather late, in 1565,
in Benzoni's *Historia del mondo nuovo*. It had already appeared
earlier in the first edition of Vasari's *Lives* (1550, 2:347): Brunel-
leschi suggested that the job of raising a dome over Florence
Cathedral should be given to whichever competitor succeeded in
standing an egg on its end on a marble slab. When everyone else
had confessed himself defeated, he, like Columbus in the later
story, performed the feat by knocking the end in. This motif,
which incidentally occurs in Calderon's *La dame duende*, apparently
had an even earlier origin, and had for some time already been
connected with the profession of the architect (Mordtmann,
1922).[4] The late sixteenth-century Turkish historian ᶜAli relates
how Constantine the Great was inspired by a prophecy to choose
as architect for the Hagia Sophia whoever should succeed in
resting an egg on its end. A young foreigner did so, having been
given a ring on which to place the egg by a heavenly apparition.
The same celestial visitant also revealed the plan of the building
to him (we have already mentioned this theme in another context;
see p. 57). The source of this story has not yet been established,

4. It was also told of an anonymous architect in Luca Pacioli's *De
viribus quantitatis*.

but it was already employed by an even earlier Turkish historian, Muhjîeddîn.

This example demonstrates that the characterization of artistic accomplishment may at times be quite unspecific, and that even a mere trick artfully performed by a juggler can serve as evidence of artistic ingenuity.

The Artist and the Public The notion of the artist's superiority to his contemporaries was expressed in a variety of ways. In general, this superiority was not directly connected with his activity as an artist. Instead, witty remarks and jokes were attributed to leading artists. In several instances, the actual personality of an artist may have been responsible for inducing the biographer to make such reports, but when one looks at the extraordinary number of such "jokes" ascribed, for example, to Giotto, who was still quoted in Florence in the sixteenth century (Vasari, 1:406), or Michelangelo, then it becomes clear that the individual trait which may have given rise to such accounts was utilized and embellished by the biographer for a special purpose.

This view is consistent with the fact that artists are often credited with jokes which are clearly of earlier origin, and often go back to unexpected sources. Thus, the King of Naples one day assured Giotto that he would make him the first man in Naples, to which Giotto replied that, after all, he lived near the Porta Reale, so as to be the first person for anyone arriving in Naples (Vasari, 1:390). This riposte was not so original, for it had already been used by Apuleius in *The Golden Ass* (1:21). This is just one of a number of such plagiarisms found in biographies of artists (see Normann, 1925).

In the context of our discussion, the roles which these elements play in the biographer's characterization of the artist deserve special attention. Generally speaking, the quick retort and the joke are indicative of an ability that operates on the basis of specific mechanisms to place ordinary things in an unexpected light. Thereby it demonstrates that mastery of the environment and that superiority over the public which not only characterize the artist to a very high degree, but which are also attributes of many other outstanding personalities.

The role assigned to the artist in comedies and farces seems to serve an analogous form of characterization: his superiority is frequently depicted in crass and obvious ways.

In a typical theme of comedies, the artist surprises his wife's lover (often with her connivance). The naked lover, usually a cleric, hides among the statues in the artist's studio. The master acts as though he were taken in and, pretending that the supposed statue needs to be improved, he threatens to castrate it with a cutting knife. We might mention parenthetically that as a result of an incorrect interpretation this farce played a minor role in the recent art-historical literature. In one manuscript the introductory words, "Do was ein maler mit wiczen," were carelessly rendered as "Do was ein maler wiczen," which led some to believe that it had something to do with Konrad Witz (i.e., "There was once a painter called Witz," instead of "There was once a painter *with* wit") (Bossert, 1920; Hempel, 1931, 94; further versions of this prank are given by Köhler, 1898–1900, 2:469f.).

While in this farce the artist comes out on top, in others he is cuckolded. There is one of a painter who seeks to insure his wife's fidelity during his absence by painting a little lamb under her navel. His successor, who usually also is a painter, has no difficulty in touching up the somewhat obliterated "picture"

before the husband's return, but he cannot resist putting horns on the lamb. In this and similar versions the story can be found in several Italian and German jestbooks (Köhler, 1898–1900, 2:611ff.). Its significant feature is that both participants are artists, and that one artist is outwitted by another.

In the majority of farces, however, the artist's butt is a layman, his public, to which he proves to be superior.

A priest sprinkled holy water on an unfinished picture and attempted to calm the enraged artist by saying that he was only performing a good deed and that every good deed would be repaid a hundredfold from above. The artist took it upon himself to make the priest's words come true: leaning out of a window he threw a bucket of water over the departing priest.

The fact that Leonardo, who recorded this jape in the *Codex Atlanticus* (1939, 2:287), could take such pleasure in it proves that this way of characterizing the artist's superiority was felt to be particularly satisfying. A large number of equally favorite stories describe the artists' cunning wiles to procure food and wine during their labors (told by Vasari of Buffalmacco, Uccello, and Ghirlandaio), rigging up dummies in front of the easel to escape the importunities of their clients (also told by Vasari of Buffalmacco),[5] and employing many other tricks to ridicule the "Philistine" (the idea was there long before the term).

This tradition was continued by stories like those of artists in Rome who pawned their stockings to pay their bills, and then used soot to blacken their legs; or of Gossaert who sold the damask intended for his court attire, and appeared in a paper costume for the Emperor's solemn entry into the city (Mander, 1906, 229, 102).

5. And of Holbein (Chamberlain, 1913, 1:123).

At the same time these stories point to the artist's special aptitude for putting every form of "deception" to use. Thus in the lowlier form of the farce we again encounter the theme of the artist's extraordinary capabilities which we have already identified in a different context.

The superiority of the artist is shown from a different perspective when he encounters the layman in front of a work of art. The central motif of this kind of episode is that the artist, with deliberate irony, places himself upon the same level as the common man, that he too leaves the "aesthetic sphere" and consciously presents a work of art as reality, thus sharply highlighting the foolishness of his critic's judgment.

When a man who had commissioned a painting from Bartolo Gioggi was disappointed because there were too few birds in the landscape, Bartolo Gioggi retorted that the birds had flown away because the servants had left the windows open (Sacchetti, nov. clxx). When two cardinals reproached Raphael for painting St. Peter and Paul with very red faces in one of his pictures, the artist replied: "That should not surprise you; I've done it deliberately. After all, one must assume that St. Peter and St. Paul are as red-faced in heaven as you see them here—because of the shame that their church is governed by people like you." (This oft-cited anecdote first made its appearance in Castiglione's *Courtier*; see Floerke, 1913, 70.) In the same spirit Michelangelo countered the objection that in his Pietà the Virgin seemed to be the same age as her Son by asking, "Isn't it true that chaste women remain young for much longer?" (Condivi, 1928, chap. 16). Giotto similarly justified the sad expression on St. Joseph's face in one of his works, claiming that the Saint had every reason to be gloomy, since he saw that his wife was pregnant without knowing by whom (Sacchetti, nov. lxxv). We believe that this

pronouncement may also be viewed as an attempt to justify an iconographic pattern that has struck many people, including Goethe (1800–16), who remarked that the painters "were out to get" St. Joseph; "The Byzantines, whom nobody could accuse of excessive humor, always show the saint as if he were annoyed by the Nativity."

The relationship between the artist and his critic found its most poignant expression in one of the most famous anecdotes about artists. When a cobbler took Apelles aside and pointed out an error in the rendering of a shoe in one of his pictures, the painter gratefully accepted the correction; but when the cobbler then went on to criticize the depiction of the foot itself, Apelles checked him with the now proverbial remark, "Cobbler, stick to your last" (Pliny, 35:85; traced back to Duris by Sellers, 1896).

As biographers present it, the artist's superiority is also evident in his conflicts with those who commission his work, especially when they are tardy in paying.

In one such instance, the artist painted bars over the portrait of the man, thus putting him in debtor's prison (Mander, 1906, 126). Or, to hasten the payment, the work was grotesquely distorted: Gillis Mostart decked out a Madonna to look like a whore (Mander, 274); and Buffalmacco painted a bear-cub over a Christ child (Vasari, 1:549). After the payment had been received, it was easy to remove the distortions since they had been painted in watercolors. According to a story told in an old German jestbook, a similar trick was played by a journeyman painter on the inhabitants of Rottweil. He painted the Flight into Egypt on one of their processional banners, but only the ass was in oil, and the rest in watercolor, so that at the first rain shower only the ass remained (Ilg, 1881, 52).[6]

6. The Cavaliere Liberi is said to have inserted an obscene detail into one of his religious paintings; originally covered by varnish, it became visible only later (Casti, 2:239ff.).

These anecdotes depicting the painter as a swindler demonstrate the disparity between him and the layman by putting the emphasis on the artist's technical devices that are unavailable to the common man. The unequal durability of the materials used makes it possible for the painter to deceive his public. Once again the figure of the artist comes very close, on the one hand, to the jester as he was shown in the medieval literature and, on the other, to the fairground juggler. The artist uses similar devices when he takes his revenge on the uninformed critics of his work; he creates the illusion of having made an alteration and thoroughly enjoys it when his work which in reality is unaltered now receives recognition.

Donatello adopted this tactic for the statue of St. Mark on Or San Michele (Vasari, 2:403), and Lanfranco for a portrait of the Vicereine of Naples that the ladies-in-waiting considered to be a poor likeness (Passeri, 1772, 152). Michelangelo strew marble dust about, pretending he had improved the shape of a nose that had been criticized (Floerke, 293). Another painter induced the subject of a portrait to stick his head through a slit in a hastily painted canvas: the viewers, who had previously seen and criticized the portrait, now at some distance believed that it was even less of a likeness than the earlier version (Floerke, 130–37).[7]

A further group of stories puts a special construction on the artist's relationship with his critics, his personal opponents.

In these accounts the artist paints his enemy in a disadvantageous light in one of his works. The most famous instance of this is Pope Paul III's master of ceremonies, who complained that Michelangelo had placed him among the damned in his Last

7. The same story is told of the French painter Jacques Autreau; see Childs (1967, 227). See also Smith (1949) on Nollekens.

Judgment. The Pope must have understood the true reason for this complaint, since he replied that this case was beyond his papal competence: the Pope had no power over Hell. This tacitly acknowledged what we too may regard as the content of the master of ceremonies' fears: that he not only felt that he was exposed to ridicule, but that underneath that superficial fear there was a much more powerful, though unconscious, dread, namely, that through the painter's deed he had in fact been banished to Hell (Domenichi, 1563, 145; Floerke, 73, 366).[8] Analogous reports were widely dispersed. Andrea Orcagna's idea of putting his friends in Paradise and his enemies in Hell clearly is taken from the *Divine Comedy* (Vasari, 1:600). Branching off from the same roots, other accounts tell us of Beccafumi who revenged himself for an inadequate payment by depicting the angels in the choir of Siena Cathedral with gestures indicative of theft (Floerke, 315, recording an oral tradition); Leonardo is supposed to have checked the nagging of the Abbot of S. Maria delle Grazie with the threat that he would put him into his Last Supper as Judas (Vasari, 4:31); and Federigo Zuccaro depicted his enemies sprouting asses' ears in a picture of Calumny (Piles, 1715, 231; Voss, 1920, 2:460). Similar things are told of Messerschmidt (1794); while Horace Vernet, in a picture of the Taking of Smalah, is supposed to have given a Jew attempting to flee with his booty the features of Baron James de Rothschild, who had haggled with Vernet over the price of a picture (Kinkel, 1876, 232); and Böcklin used the wife of a cheating picture dealer as the model for a Susannah and the Elders, very much like Girodet who depicted a greedy actress as a Danäe (Hartmann, 1917, 166; Nagler, 1835–52; Lecomte, 1913, 15 [*The Age of Neo-Classicism*, Exhibition, London, 1972, no. 109]).

These few examples demonstrate the persistence and particularly widespread diffusion of this theme. It is clear

8. Peter von Cornelius is said to have put Goethe and Schiller among the damned in his fresco of the Last Judgment (Schlosser, 1924, p. 227).

that in some instances the assumed relationship was read into the work only subsequently, as when Guido Reni was asked by Malvasia (2:29) if he had really given the Satan in his famous picture of St. Michael the features of Cardinal Pamphili, and denied the rumor as an invention, but added: "se per la sua deformità incontrava in quel ceffo diabolico, non era colpo del penello" ["if his deformity appeared in that diabolical face, it was not the fault of my brush"]. A story told of Menzel seems to belong in the same category. The artist once found himself at an inn at Kissingen, where a woman in a party at the next table made fun of his appearance. Menzel began to draw in his sketchbook, and since it was assumed that he was drawing the woman, one of her male companions passed on the woman's request that he desist from drawing her. Whereupon Menzel displayed the drawing, which showed a well-cropped goose (Hartmann, 1917, 138).

An attempt to get at the core of these stories once more points in the direction of the by now familiar idea that in his works the artist practices magic. The belief in the magic of images lives on in the model's fear of being distorted.

The accounts of models being distorted and parodied also can be traced back to their origin in antiquity. For Ctesicles was availing himself of the same device when, to revenge himself on Queen Stratonice, he painted her in the arms of a fisherman and exhibited the picture publicly (Pliny, 35:140).

Here, however, the belief in the magic of images operates only as a psychological backdrop, against which the outline of a new art form begins to emerge. The fact that Queen Stratonice did not permit Ctesicles's picture to be destroyed signifies the recognition of a new mode of artistic expression,

which was fully established by the time that Menzel drew his woman as a goose—namely, the art of caricature.[9]

The motif adopted by biographers to indicate the artist's superiority can also be found in another literary category that devoted a great deal of attention to the artist—Italian Renaissance fiction. While in the fourteenth century Bruno and Buffalmacco were the heroes of tales by Boccaccio and Sacchetti, in the sixteenth century their place was taken by Piloto, Scheggia, Tasso, and Tribolo in the writings of a Grazzini. Many of the escapades in which the artists become involved were standard features of classical comedies, but in many cases they served to indicate a special trait of the artist. Bruno and Buffalmacco talk the much stricken Calandrino into believing that he is invisible or even pregnant. Botticelli sticks little red paper caps on the angels in a picture of the Madonna painted by one of his pupils, removes them, and then succeeds in convincing his pupil that he must have been suffering from delusions when he claimed he saw the red caps (this motif, originating in fiction, seems to have found its way into Vasari's *Lives* [3:319]). Of the same order are stories like one of Sacchetti's (nov. cxci; Vasari, 1:499), in which Buffalmacco, who is aroused by his teacher in the middle of the night and bidden to paint, managed to convince him that anyone painting at night would be assaulted by devils. Similarly, Grazzini relates a tale about Scheggia and Pilucca who, in order to win a bet, made out that their partners were mad (Floerke, 183). The common element in all these pranks is that the butt of the artists' ridicule is made utterly uncertain about what is

9. A topic to which Kris devoted several studies; see Kris (1934), Kris and Gombrich (1938), Gombrich and Kris (1940).—*Editor's note*

reality and what is illusion. This is also the central theme of the most beautiful and grandest of the Florentine novellas devoted to artists, the one of the "Grasso Legnaiuolo," or the stout joiner, which is thought to have been composed by Manetti, the friend and biographer of Brunelleschi, for the simple reason that Filippo Brunelleschi plays a leading role in it (Floerke, 141–58 [Barbi, 1927, 133–44; Varese, 1955, 767–802]).

At the latter's instigation, abetted by Donatello and other members of a dining club, Manetto the joiner was to be taught a lesson, because he had not turned up at one of their parties. So the artists decided to talk him into believing that he was not himself, but a certain Matteo, whose life he was induced to lead for two whole days by means of great cunning and carefully contrived prearrangement. Trick was piled on trick, ending in the unfortunate hero's being brought back stuporous to his own workshop, and being told when he awoke, in order to complete his confusion, that for two days somebody else had pretended to be him and played the part of Grasso Legnaiuolo. Once awake, however, Manetto can no longer find his way back into his own life; and the reader, engrossed in the lively account, is grateful that Manetto decides to take his leave, not of life, but only of his homeland. To escape his memories, the stout joiner moves to far-away Hungary.

This fascinating motif was used by Sem Benelli (1910) in his novella, *Cena delle beffe* [*The Mockers' Repast*].

In modern times experiences such as Manetto's have frequently been treated as the product of a diseased mind, as a sense of alienation. In the writings of Dostoevsky, for example, they are the subject of an epic presentation. In the novella of the stout joiner, however, the feeling of alienation—of depersonalization— does not derive from a pathological alteration within the in- dividual, but is imposed on him from without. The possible

objection that we lack any clues as to how such experiences were evaluated in the Renaissance can be countered with a quotation from the *Dialogues* of Erasmus of Rotterdam: "While I do not know if there are many people who would exchange their body for another's, if God were to allow them to, I am sure that there are still fewer who would make an exchange of their character and intelligence" (Zilsel, 1926, 225).

These themes can be distinguished from others in which contemporaneous Florentine fiction involves the artist. While the burlesque seeks to underscore the artist's wit and inventiveness, casting the regular characteristics of the rogue of medieval farces in the lively local color of Tuscany, the group of themes centered around the tale of the stout joiner has a different element in common: all the victims of these artists' pranks become confused in one way or another; they are talked into believing and are finally convinced that they are mad; they have all been victims of magic—they are transformed by magic.

Sketching out a broad area, we can connect this characterization of the artist customarily given in fiction with other, familiar elements used in biographical descriptions of the artist. The deception that he practices in the novella may be compared with that ascribed to him by the anecdote of the deceptive power of the image. This is no mere analogy, for the ability to create the illusion of reality, which turned up in Hellenistic biography as a feature borrowed from the figure of the mythical artist, was depreciated by the ideology of the Middle Ages which regarded the artist as a dangerous magician. This conception did not enter into the biographies of artists when they were revived in the Renaissance and served the function of heroization. Yet the image of the artist as a dangerous magician emerged from time to time

from half-obliterated sources. Rooted in popular beliefs, it was responsible for some of the legends that grew around the artist. As a characteristic example, we insert an account which appeared in 1552 in Antonfrancesco Doni's "Marmi." It describes the impression created by the Sagrestia Nuova and already was widely disseminated in Michelangelo's lifetime.

A Florentine and a stranger entered the Medici Chapel. Seeing the Aurora, the stranger was rooted to the spot. Thereupon the statue began to speak, saying that only a short while ago another stranger with a discriminating mind had accompanied Michelangelo on a visit to the chapel. "After he had gazed at everything, and gazed afresh, his eye remained riveted to my sister, Night, whom you can see over there. His soul was entranced, and he could not move, but Michelangelo did not rouse him from his trance, for he had no power over one of God's creations, though he did over his own. So he let Night raise her head and move. At this the visitor came to. And so he recovered his senses, owing to the magic powers of the divine man. But Night let her head sink back, and as she moved, her left arm broke. So Michelangelo had to make her another, as you can see for yourself." On this occasion, because Michelangelo was not there, Aurora had to move of her own accord to wake the nobleman (Thode, 1908, 4:525).

The central motif of this story is concerned with the effect produced by works of art, and appears, as is often the case in legends, fairy tales, and above all dreams, in the form of a "double elaboration." In the story within the story, the point is made more directly: an onlooker is frozen to the spot by the sight of one of Michelangelo's statues, and only the work's creator can break the spell. The "magic powers of the divine man," however, are to be taken not figuratively,

but quite literally, as a genuine capacity to cast a magical spell. The framing story makes the same point, but in allegorical form: rooted to the spot by awe and wonderment, the onlooker is recalled to life by the liveliness of the work of art. This idea is distinctly reminiscent of the magnificent allegory by means of which Michelangelo himself described, in unforgettable verse, the significance of the statues of the Sagrestia Nuova. But we must stick to the undisguised method of representation and may regard it as evidence of the polarity governing the image of the artist that is was just Michelangelo who, heroized as the "divine" artist like no other man, was on a deeper level depicted as a magician, in legends that arose even within his own immediate circle of acquaintance.

Lucian (*Quom. hist. conser.*, 62) informs us that Sostratus, the architect of the lighthouse of Pharos, one of the Seven Wonders of the World, inscribed the name of his ruler only on the perishable plaster, but he incised his own on the durable stone beneath.

We have already encountered, in another context, the device employed here by the architect—it has to do with the variations in durability of different materials, of which the layman is ignorant. In this instance, however, this knowledge is not used in the service of a farce. Rather, the report characterizes the artist's attitude to his own work. The artist, intent on securing his own fame alone, asserts at the same time that the work of art belongs exclusively to him. This attitude is clearly reflected in biographies, as the following examples demonstrate:

Donatello demolished the head of his Gattamelata, because he was excessively harried by those who commissioned it. In re-

sponse to the threat to lop his head off just as he had decapitated the statue, he was supposed to have retorted: "That is quite all right by me, just so long as you trust yourselves to put my head back on again, as I shall that of the commander." This story is to be found in a Quattrocento Florentine jestbook, the *Diary* attributed to Politian (Wesselski, 1929, 27ff.).[10] In Vasari (3:368), Verrocchio appears as the hero of this incident, slightly altered in minor details. If we consider the general tenor of the *Diary*, there is much to suggest that the story was prompted by an actual occurrence in Donatello's life, and it was in fact Donatello who, according to Vasari (2:407),[11] destroyed a bronze head for which a Genoese merchant refused to pay. In the nineteenth century such reactions were regarded as characteristic of the artist: "Pinelli ... was the perfect prototype of the artist as the good bourgeois imagines him to be ... his haughty presumption of destroying works for which inadequate payment was offered—all contributed to the esteem in which he was held" (Baudelaire, 1923).

The attitude attested to by these and similar motifs—and here one should also cite the mentally ill Messerschmidt who wanted to destroy his works before his death (Kris, 1933)—leads to the conception that the artist, as the creator of a work of art, has sole power over his creation.

The artist's demeanor that is produced by this conception, however, derives from the deepest psychological pre-conditions of his creativity; at the same time it gives rise to and causes the numerous difficulties he encounters in his life. If ever the whole problem of the extent to which the artist's activity is fostered or thwarted by the circumstances in which

10. See also Gelli (1896, 60); Poliziano's so-called *Diary* is discussed by Folena (1953).

11. Vasari (5:377) reports a similar story about Matteo del Nazzaro who destroyed a cameo he had made.

he has to work receives the comprehensive historical treatment it deserves, its key element will be the running battle with his clients. Biographies treat this conflict as a common everyday occurrence.

The stingy client becomes a stock figure; for instance, when he asks an artist to paint for him something with which he is not familiar, he gets an Allegory of Generosity (Floerke, 1913, 292). More recently this story has also been told of the painter Oppenheimer (see Roessler, 1924, 92). The artist must frequently defend himself against his client's mistrust—a theme that frequently cropped up in Renaissance comedies. For example, Perugino (and similarly Albani) showed a niggardly client the deposits of ultramarine blue that he had collected in a bucket by frequently washing his brushes (Vàsari, 3:575; Passeri, 282). The relationship is often reversed, with the artist being portrayed as a miser. Here too we come across stereotyped formulas, of which the following is an example. Rembrandt is said to have altered his etchings only as a result of his avarice and desire to fleece collectors who were eager to possess the different plates. In a variation of this theme, Rembrandt is said to have organized an auction of his works, pretending that they were by an artist who had died. The history and transformations of this anecdote were traced by Carl Neumann (1927). [Addenda can be found in Baudissin (1936).]

If we attempt to pursue this at a higher level, we arrive at the outlook of the Greeks, who could not reconcile the idea of creation under the auspices of divine inspiration with monetary reward for the work created. It is generally reckoned as one of the reasons for the Greeks' relegation of figurative artists to the rank of the artisan that they, unlike poets and seers, were paid for their productions.

Once again we are brought up against a complex issue

which our material does not enable us to do more than touch upon. Even in our own days society still retains the belief that renunciation and poverty are the lot of the genius. This concept of genius is by far the most common one and seems to be connected with the expectation of an ascetic way of life which the religious fervor of the Middle Ages demanded of the hero of its beliefs and which in the Renaissance was transferred to those blessed with genius.

Within the frame of Western culture, this attitude no longer appears as a fixed motif in the biographies of artists, but it can occasionally be demonstrated in the case of certain individuals; it is equally easy, as we have seen, to produce instances to the contrary, exemplifying the wealth and social success of the artist. On the other hand, this attitude typifies the image of the artist in Chinese biographies. Like the great poets, in China the great painters live like hermits, in the solitude of nature, from which they draw their inspiration. They do not seek honors and wealth, they avoid the climate of the court, and they give away their pictures. This motif also is recorded in anecdotes. It is related of T'ao Hung-ching in the sixth century that he resisted all the attempts of the Emperor to entice him to court; finally, he sent the Emperor a picture showing two oxen, one which was freely roaming the meadows and thickets; the other was splendidly tamed, but forced to obey the ox-herd's goad (Giles, 1905, 31).

Life and Works The riddle bounded up with the work of art and the mystery of its origin in the mind of its creator have determined the image of the artist as it has passed into the historical record. We have unearthed some of the roots of this image. We have

attempted to show the depths from which it comes, and how ancient ideas carrying the imprint of myths are perpetually renewed in it. The task that we now set ourselves is of a different kind: we want to establish how the aura of power and mystery that surround the artist is expressed in the literary traditions. Our investigations have led us to two central ideas around which the motifs of biography appear to cluster: one attempts to make the process of artistic creation comprehensible through the use of analogous life experiences; the other endeavors to establish a direct link between the artist and the work of art. As an example of such biographical approaches, we may take the tradition—one that extends from classical antiquity into modern times—which regards the work of art as the "child" of the artist and attempts to view the process of artistic creation according to the model of sexual life.

A painter is asked how it is that his own children are so hideous, when those that he paints are quite the opposite. The reason, he replies, is that he engenders the latter by daylight, but the former at night. This quip derives from a classical source, the *Saturnalia* (2:2.10) of Macrobius, where it is attributed to the Roman painter Lucius Mallius. It is cited by Petrarch in one of his letters, when he comes to speak of the unappealing exterior of great artists. In the fourteenth century this ancient anecdote is still told, this time of Giotto, with Dante as the questioner (Schlosser, 1896, 348). Thereafter it often crops up in both Italian and German jestbooks (Pauli [1924, 2:357], who lists an extensive biography [see also Tubach, 1969]). In a slightly modified form it was also attributed to Michelangelo. When he made the acquaintance of the handsome son of Francesco Francia, he dispatched him to his father with the message that Francia "was better at producing living than painted pictures" (Steinmann and Wittkower, 1927). Another remark of Michelangelo's

shows us this anecdote in a different interpretation. When he was asked why he had never married, Michelangelo indicated that his works were his children (Condivi, chap. 58; Vasari, 7:281).

It is only in this century that the comparison between artistic and sexual creation—here espoused by popular opinion as an explanation—has been approached scientifically. The concept of sublimation provides part of the answer, even though hasty adoption and sloppy use in everyday language have unrecognizably distorted this concept which psychology is still uncovering painstakingly. Sublimation points to a connection between creative activity and the sexual drives; in using it, however, we do not aspire to do more than offer a hypothesis, formulated in terms of psychic energy, concerning one source of creative activity in general.[12]

Another belief related to the idea that the artist's work has sexual significance is also rooted in popular opinion. It assumes that a beautiful woman in a painter's picture is his mistress.

It is said that Praxiteles depicted Phryne as Venus; Hugo van der Goes placed his mistress in the picture of the Encounter of David and Abigail (Mander, 1:53ff.); and Bronzino painted his beloved as Eve in the picture of Christ in Limbo (Misson, 2:339). This motif in particular was again and again elaborated in many variations in guidebooks that abound in cherished legends and fables. Dispensing with the numerous examples that could be cited, we refer only to the opinion according to which Goya's clothed and unclothed Maja was the Duchess of Alba (Kehrer, n.d., 50 [see also Harris, 1969, 86f.]).

12. The relevance of the psychoanalytic concept of sublimation to the creative process was treated in detail by Kris in 1952.—*Editor's note.*

In verses dedicated to Praxiteles and Hugo van der Goes which Mander included in the biography of the latter, Lukas de Heere lauded the figures portrayed by these masters, asserting that their lovely countenance conveyed the love that had guided the artists' brush.

Thus, in the eyes of the biographers, love is the impetus to artistic activity—love for the beloved; at this point it is permissible to recall, as a never-forgotten counterpart, the myth of Pygmalion.

The artist's love for his model, which was originally emphasized in order to "humanize" the artist's attitude to his work, later came to be associated with the popular view of the artist's character. It was linked with the idea of greater sexual license that society granted the artist. In earlier biographies this sphere was only hinted at, and seemed, as in the life story of Fra Filippo Lippi, to have been directly related to a particular character trait of individual artists. In the sixteenth century, when the painter and sculptor were accepted as members of the community of creative genius, the question assumed a wider significance, until ultimately in the Romantic era dissoluteness as well as sexual license became bywords for the artist. What appeared as an isolated element in Renaissance fiction—one instance is Bandello's novella no. 23 (in vol. 3)—subsequently became a fixed feature of the image of the painter's character. Thus E. T. A. Hoffmann (1857) could have one of them say: "I'm a painter, so there is nothing to be done for it but to fall hopelessly in love with a beautiful young lass and paint her portrait. And indeed that's what happened to me."

Pliny (35:119) says of the painter Arellius that he brought dishonor upon art, "because he fell in love with every woman. He therefore painted goddesses, with his mistresses serving as models"; as a result, it was easy to count his mistresses. What the Romantics regarded as the artist's prerogative was viewed as an aberration in antiquity.

The artist's relationship to his model was also shown in other contexts in biographies. We give two examples of this typical theme.

The uniformity of the type of women painted by Perugino was explained as the result of the artist's repeatedly painting his own beautiful wife—a view that is explicitly stated in the biography of Albani (Piles, 1715, 165, 321).

Another set of stories presents a series of variations on the theme. One of them has it that Michelangelo bound a young man to a cross and killed him, in order to depict his death agonies in a work of art. This legend, which seems to have made its first appearance in a seventeenth-century English book, Richard Carpenter's *Experience, Historie and Divinitie*, was even then juxtaposed with an analogous tale from classical antiquity (Steinmann and Wittkower, 1927, no. 419 [Sandrart, 1925, 270, 413]). Parrhasios is reported to have bought an old man, one of the Olynthian prisoners sold at auction by Philip of Macedon, and to have tortured him to death. This story, which we owe to Seneca (10:34), makes the artist, eager to study the effects of pain on the human face, into the murderer of his model (Overbeck, no. 1703). Yet it is a story that comes up again and again. The guidebooks connected it with three different works attributed to Michelangelo: a head of the dying Savior at San Marco in Florence, and the crucifixes at the Palazzo Borghese in Rome and San Martino in Naples (Keyssler, 2:62, 2:350f., 3:94). But the legend can be pursued even farther afield. It is told about a crucifix at the Marienkirche in Danzig (Lindner, 1903, 19; 1904, 534); about another made of papier-mâché in the private chapel of the Carmelites at Brussels (Keyssler, 2:322); and about one by Daniele Crespi (Nicodemi, 1931, 26).[13] Exactly the same story is persistently told in the biographical fragments

13. The story of a sculptor, his crime and his penance, is the topic of Chamisso's poem *Das Crucifix: Eine Künstler-Legende* (*Gedichte*, 505ff.).

which at the end of the eighteenth century grew up around the figure of the Viennese sculptor Franz Xaver Messerschmidt (1794). A related version of this tale is also told of the doctor who killed a pilgrim in order to study the "circulation of the blood" (Engelmann, 1904, 154).

Different as the gist of the two sets of motifs may seem, there is nonetheless a connection between the two. Both involve attempts to draw conclusions about the circumstances of the artist's life from his works. In the first set, the master's style, his ideal type, is explained as the result of individual features of his model—an approach that was particularly prevalent in the seventeenth century; in the second, the stark effect of many works of art evoked the notion of a murdered model and thus the awe of the artist that had attended him all along. Both instances exemplify attempts to explain the artist's relationship to his work in terms of stimulations emanating from his model. The attitude this represents has influenced biographers more profoundly than in the mere adoption of typical formulas.

Repeatedly we encounter attempts to link the character of the artist with that of his works, and to infer the nature of the man from his works. It would be well worth examining this thesis in specific cases, for example, in the biography of Raphael, but such an undertaking exceeds the scope of our investigation and would, moreover, force us to go beyond our methodological basis. However, one principle must be spelled out. This kind of reasoning practiced by biographers proceeds from the premise that the human foibles of the artist persist in his work; however, "alongside the traditional stereotype of concordance between art and life—and it is perhaps the least substantial and the least precise—other

relationships between the artist and his work can be demonstrated, among them that art provides a means of escape from life" (Lalo, 1933). Popular opinion has without restraints embraced the first point of view and is bent on finding its cherished image of the artist in his work. And in the face of unfamiliar and not easily comprehensible features of a work of art, the explanations resorted to reach for abstruse hypotheses, the most notorious of the kind being that which seeks to account for El Greco's style in terms of his supposed astigmatism.

Once again we can point to precursors. Vasari (2:284) relates that Parri Spinelli had painted all his figures shying away to one side, and with a nervous and terrified look, ever since he was attacked by robbers.

Such references to physical defects and psychological traumas also serve the function of linking the artist's person with his work. This approach persists in highly controversial "pathographic" analyses, which ultimately again insist on seeing the artist's life and work as one and the same thing. New avenues of approach have suggested themselves only recently when modern scientific psychology established the fact that personality is much more complex and structured differently than popular psychology customarily assumed.

Several of the biographical motifs that we have examined are set in a context that itself merits investigation, namely, the rivalry between artists.

Just to remind ourselves, we might mention the competition between Zeuxis and Parrhasios over whose works had the greater deceptive power, or the rivalry between Apelles and Protogenes over who could draw the thinnest line. In

attempting to explain why the anecdote is couched in these terms, we point to two factors: the part played by competitions in Greek culture generally, and the historian's penchant for bringing two leading figures together in this way. The validity of this derivation is borne out by the fact that competition between creative individuals is not confined to the realm of the visual arts. Perhaps the most famous example of this literary device is the story of the challenge between Homer and Hesiod.

We certainly do not deny the frequency of rivalries between artists, but merely want to make the point that biographers liked to weave such competitions into the lives of artists. The story of Brunelleschi and Donatello striving to outdo one another in making their crucifixes (Vasari, 2:333, 2:398) can safely be considered a biographical device, just as the report of the rivalry between Dürer and Lucas van Leyden, which was probably occasioned by the observation that the Dutchman had borrowed compositional motifs from the German (Vasari, 5:406). In many of these stories a visit to the rival's studio is placed into the foreground, as was the case in the tale of the "thinner line." Thus van Dyck visited Frans Hals's atelier as an anonymous client, had his portrait painted, and only when he in turn painted Frans Hals was his anonymity exploded (Houbraken, 1763).

One should note that the rivalry is not always expressed in such a pacific form, but rather serves to unleash the passions of the competing artists. Its mildest form probably is criticism of the rival's work, a disparaging remark about his creation or person.

Donatello, asked to appraise a statue by Nanni di Banco, put a very high price on it because "This worthy man is not my equal in art, and his work costs him far greater pains than does mine. Hence, as fair-minded men, you are bound to pay him for the

time he has spent, if you want to do him justice" (Vasari, 2:216). Another of Donatello's remarks concerned a long-shrouded fresco by Uccello. When the latter showed it to him, his reaction was: "My dear Paolo, you are unveiling your picture now when it would be high time that you covered it up" (Vasari, 2:216). In the same vein, Raffaellino da Reggio responded to a request by a certain Riccardo Sani to tell him which was the best face in a picture that he had painted by pointing to a figure seen from the rear [Noe, 1954, 304].

The essence of these antagonisms is expressed more clearly in an anecdote relating that Michelangelo destroyed pictures by Dürer out of envy—an assertion whose accuracy was the subject of lively debate in the seventeenth century (Fuhse, 1895). Other stories enable us to see that here the rival's work is a substitute for his person. Repeatedly biographers voiced the accusation or suspicion that an artist murdered his rival.

The classic example is the frequently told story of Andrea del Castagno's murder of his friend and collaborator, Domenico Veneziano, who in fact outlived him by four years (Vasari, 2:678). One of the greatest Chinese painters, Wu Tao-tzŭ, was likewise accused of having disposed of a rival (Giles, 1905, 48). Accounts of artists being poisoned by their envious antagonists play an especially prominent role. Thus Pordenone, Peruzzi, Barocci (Piles, 1715, 210, 235, 276), Lucas van Leyden (Mander, 1906, 58), and Simone Cantarini (Baldinucci, 4:48) are all supposed to have been poisoned by those who resented their success. One should, however, remember that the fear of being poisoned by a rival may not always have been so baseless; Dürer wrote to Pirkheimer from Venice that he had been warned against eating with the local painters.

The accounts dealing with the relationship between teacher

and pupil constitute a special category. These too can be traced back to antiquity.

"To this day two amphorae are exhibited in the Temple of Erythrea, to which they were dedicated on account of their thinness; they were the result of a competition between master and pupil as to who could throw the thinnest clay" (Pliny, 25:161). Occasionally the rivalry eventuates in the death of the pupil. Thus Daedalus is supposed to have killed his nephew and pupil Talus out of envy (Pauly, 4, col. 1996). The following motif is frequently encountered in medieval tales. The builder of the cathedral murders his apprentice for surpassing him (Ilg, 1871, cl; Kinkel, 1876, 189ff.; Coulton, 1912, 344 [Hasluck, 1919, 315; Thompson, 1955–58, 5:497; Talos, 1969, 200]). A witty observation in Lucian's *Dream* demonstrates that the teacher's competitive attitude to his pupil already was a legendary theme in antiquity. As an apprentice sculptor he was given a thrashing by his uncle and master for spoiling a marble slab; back home, however, he gave as the reason for his punishment that the master was "concerned lest he should surpass him in his art."

We are confronted by the question why the motif of the artist's rivalry should have established such a firm hold on biography. We feel justified in proposing an additional explanation to those already given. The artist's alleged readiness to dispose of his opponents may be understood by considering his special relationship to his work, the crucial importance of creative activity to his inner life; and that the heightened passion with which he encounters his rivals results from his striving to insure the uniqueness of his achievement. If we are to judge by the evidence provided by biographies, this attitude on the part of the artist is dependent neither on the form of art practiced, nor on the

degree of individuality or self-expression embodied in the work of art. Once again we are faced with a state of mind which is not peculiar to the figurative artist; that is to say, not only does the competition between master and pupil reflect the perpetual conflict of generations evident in both myth and life, but the painter's or sculptor's jealous defense of the uniqueness of his own works is common to all creative individuals. The attempt to offer any further explanations would lead us into the psychology of creative ability.

Here we may content ourselves with the observation that the craft of the artist, like that of many artisans, was held to be a closely guarded secret.

The ancientness of this attitude is evident from an Egyptian Middle Kingdom tomb stele, on which the painter and sculptor 'Ertesen boasts that he knew how to represent his figures standing still and in motion, and that he was in possession of technical secrets which he passed on solely to his eldest son (Ermann, 1923, 305ff.). The Telchines of Greek mythology also were concerned with jealously guarding the secrets of their arts (*Diod. Sicul.*, 5:55). The vital role played by this outlook in the constitution of masonic lodges in the Middle Ages is well known. It survives in biographies in the shape of assertions that Jan van Eyck discovered the secret of painting in oils—and bequeathed it to Roger van der Weyden, according to Carel van Mander (1906, 16);[14] or that Giorgione barred the young Titian from his house so as to preserve the secret of his new technique of painting (Piles, 246, 251).

It is this aspect of behavior that gains special prominence in literary depictions of the artist. In Balzac's *Chef d'oeuvre inconnu* the fantastic painter Fernhofer is said to have learned

14. Actually, Mander calls him "Rogier of Bruges" and devotes a separate piece to "Rogier van der Weyde."

the secret of "how to instill life into painted figures" from Gossaert, and Poussin tries to get him to hire his mistress as a model so as to acquire the secret. The artist's secret is his art, and the words that Balzac uses betray the view that the work of art is admired for its power to convey life—we may say, for the sake of its magic aliveness.

The stuff of biography provides only minimal access to another issue—how the artist's work evolves, and what inner processes it entails. Appeles' maxim "Nulla dies sine linea" has become the proverbial model of analogous accounts (Pliny, 35:84). Yet, this characterization too is not confined to painters and sculptors; zeal and industry are common to all who are involved in creative efforts.

When we hear of Protogenes calmly continuing to work when Rhodes was besieged (Pliny, 35:106), or of Parmigianino doing the same when the Spaniards took Rome in 1527 (Vasari, 5:225), we know that these reports are modeled on the famous story of Archimedes' reaction to the invading troops. The idea that the artist involved in his art is dead to the world outside appears in many guises: King René paints on unmoved by the news of the loss of his principality (Wurzbach, 3:136); Uccello devotes himself to the study of perspective with such passion that he neglects his sleep and ignores the enticements of love (Vasari, 2:217); Brunelleschi forgets food and sleep while he studies the remains of ancient Rome (Vasari, 2:337); and, to cite an example from a later period, we again refer to the biography of Messerschmidt (1794), who as a boy neglected his meals so as to pore over a treatise on anatomy.

It is not a coincidence that the kind of behavior described in these anecdotes recurs as a caricature in the comic figure of the absent-minded professor, for what these biographical

reports highlight as the essence of the creative urge of the artist puts his work on a level with that of the scholar.

That biography conveys such an inadequate or one-sided idea of the nature of the creative process can be accounted for historically. The notion that the artist is dead to the world when he is engaged in his art, that he creates from within himself, took shape at a time when the biographical formulas, which are what we have to go on, had long been coined. From the Renaissance onward this notion gained increasing acceptance, so that in the context of European culture one can speak of an increasing subjectivity, an increasing impregnation of the work of art with features deriving from the individual personality of the artist. This development, which was completed only toward the end of the nineteenth century, culminated in the tendency to view the work of art more and more as an expression of the artist's "soul." As we have already tried to show, the roots of this outlook go back to the Platonic and neo-Platonic theories of the artist and his creativity which were revived in the Renaissance and fused with the idea that the artist listens to an inner voice. We draw attention to this link once more because it serves as a background to a particularly characteristic description of an artist's conduct.

In a letter published some years ago, the painter Giulio Clovio describes a visit to El Greco. On a beautiful spring day he called on El Greco with whom he wanted to take a walk, but found him sitting in a chair in a darkened room. "He was not working, nor was he sleeping. He did not want to come out with me, because daylight would disturb his inner light" (Kehrer, 1923, 784f.).

Our treatment of this fascinating document as an item of biography, and of modern biography at that, requires special justification. The reason is that subsequent research, as Julius

von Schlosser has kindly informed us, has revealed that the whole matter is a mystery; that there is no such letter in the Spalato archives, where it was supposed to have been; and that it must be regarded as an invention of the student who brought a translation of this "document" to El Greco's biographer. The student's inventiveness here assumes the role played by the typical legends in biography. Nor is it discredited by the fact that the origin of the letter is mysterious; indeed, that Panofsky (1924) was led to adduce this document as an illustration of the artistic theory of Mannerism demonstrates how profoundly modern ideas of the special character of artistic creativity are rooted in the notion of the inner voice of the artist, the "inspiration" of the *divino artista*.

This image of the creative process—an image that is still active among us, though it originally grew in the soil of classical traditions—should be compared with that of Chinese Taoism. It centers on the artist's absorption in his work; in contrast to Western tradition, however, this motif has been converted into a biographical formula in China.

Chinese painters are said to have lived for weeks on end in the mountains and forests, among animals, or even in the water, in order to lose themselves completely in nature. Mi Fei called an oddly shaped rock his brother; Fan K'uan (circa 1000 A.D.) lived in the mountains and forests, often spending the whole day upon a crag and gazing about him, just to drink in the beauty of the countryside. Even when there was snow on the ground, he would wander to and fro by moonlight, staring determinedly ahead, to achieve inspiration. Kao K'o-ming (tenth century A.D.) loved darkness and silence; he used to roam about in the wild and spend days on end contemplating the beauty of peaks and woods, oblivious of himself. When he reached home again he retired to a room where he would not be disturbed and allow his soul to pass beyond the bounds of this

world. In this condition he produced his pictures (Giles, 1905, 86, 99, 115).

We learn from these accounts that the artist seeks either solitude or stimulation by music or intoxicants as a prerequisite for the creative act.

It is related of Ku-Chün-chih (fifth century A.D.) that he erected a kind of platform in his house, which he used as his workshop. He would climb up to this loft, draw up the ladder behind him, and then was not seen again by his wife and children for many a long day. Hsin Ch'ang (fifteenth century A.D.) was incapable of painting when anyone's presence disturbed him (Giles, 1905, 25, 152).

Wu Tao-tzŭ used to get intoxicated before setting to work. It was said of Chih-hui that, when "elevated by wine, he held the clouds and the hills in the hollow of his hand." Li Ch'êng (tenth century) had to be plied with drink until he was tipsy; then, and only then, did his brush get moving. Kuo-Shöng, a landscape painter of the T'ang Dynasty, used to spread silk on the floor and mix his colors. He had a group of musicians play to him and drank until he was intoxicated; then he began to draw in the outlines and the colors and mountain peaks emerged as if by magic (Giles, 1905, 43, 75, 84; Fischer, 1912, 16).

What distinguishes these accounts from Western ideas is perfectly clear. As Otto Fischer (1912) said, they speak of "the Taoist-inspired endeavor to interpret art as the revelation of Being through a human medium. . . . Since indeed the aim of Chinese art has been to render visible the Life Force of Nature, it is understandable that art has had to appear as a spiritual revelation of Nature."

We shall not attempt to go more deeply into the origins of this Chinese tradition or delineate in detail how it differs from those of the West. It is not far-fetched to assume,

however, that these two anecdotal traditions reflect fundamental differences between two divergent pictures of the world. In the civilizations that originated around the Mediterranean basin the belief in the creation myth overshadows everything; in those of the Far East, in which the idea of a creator god may belong to an earlier stratum of tradition, the dominant belief is in the unity of man and cosmos, as taught by Taoism.

Of all the efforts to obtain some understanding of the creative process, those recorded in the Far Eastern anecdotes appear to be the most impressive. The Chinese conception of the artist's ecstasy as a state in which the ego expands its boundaries, consciousness relinquishes its ties to reality, and the work being created is experienced as an extension of one's own person—all these seem largely to be in agreement with the psychological insights that are just beginning to be gained.

This state is described in two reports, both from the writings of Su Tung P'o (1035–1101) (Ku Teng, 1932, 109): "When Wen Yü K'o painted bamboo, he perceived only bamboo in front of him and no people; not only did he see not people, but he lost all sensation of his own body, which also became bamboo. He thus became a new being." And, "When Han Kan painted horses, he himself became a horse."

We resume the thread of our earlier argument. This Chinese anecdote depicting the phenomenology of a particular type of artistic creativity lends a new and deeper meaning to the idea of the work of art as an extension of its creator, as a child of the artist. This special relationship between the master and his creation determines the artist's reaction to the success or failure of his work.

Cimabue left any picture unfinished on the spot, no matter what the cost, if he or someone else discovered some defect in it (from the so-called *Ottimo*, cited by Vasari, 1:257). The same phenomenon is involved when we read that Verrocchio renounced all activity as a painter once he had perceived Leonardo's superiority (Vasari, 3:366), and that Francia died of a broken heart after Raphael's "St. Cecilia" had made him aware of his own inadequacy as a painter (Vasari, 3:546).[15]

The rivalry between artists, in these and similar stories, may be viewed as an additional motif, because the notion that the artist seeks death when he believes that he has failed in his work appears in many versions.

Giotto, as the architect of the campanile at Florence, is supposed to have volunteered to die when the construction proved faulty (Wickhoff, 1889, 229; Floerke, 1913, 229). According to local Viennese word-of-mouth traditions, Fernkorn committed suicide when his monument to Prince Eugene of Savoy was found to be out of balance, and so did Zauner because he had forgotten to put horseshoes on the equestrian monument of Joseph II.

Similar stories are particularly apt to be told of architects. One could find examples from every period in the guidebooks to almost every town. We select one of them, for its relevance to other typical themes that are widely circulated in biographies.

The erection of the Atmeidan obelisk in Constantinople appeared to founder at the very last moment, when an apprentice intervened with the suggestion that the ropes be shortened by wetting them. Ashamed of being shown up by his apprentice,

15. See also Chamisso's poem, *Francesco Francias Tod*, cited earlier. Carlevari's death was ascribed to apoplexy brought on by the success of his pupil Canaletto (Levey, 1959, 81).

the master threw himself down from the top of the obelisk. Here the motif of the artist's suicide is linked with the anecdote of the "Erection of the Obelisk," whose migrations have been pursued by Huelsen (1921).[16]

The frequency of such episodes in the biographies of architects may be attributed to a survival of the ancient view, according to which the erection of a building is an affront to the gods and must be atoned for by a sacrifice—a view still visible in Ibsen's *Master Builder* in which the architect-artist Solness requites the deity for his building with his life. But even if we leave this bold hypothesis aside, the reports about the suicide of architects once more underscore the intimate bond linking an artist to his work. Their shared fate is illustrated in the following unemotional account by a reliable chronicler (Ghiberti, 1:43), which we cite in conclusion:

Gusmin, the goldsmith, retired to a monastery when a piece he had made for the Duke of Anjou had to be melted down. He departed from this world along with his creation. The inner life of the artist is bound up with his work; creator and his creation are irrevocably linked. It is this fact that the biographical formulas of the artist's death attempt to encompass. His sensitivity, vanity, and arrogance all assume a tragic dimension. In this formula, the special position of the artist is made particularly clear in that it ascribes the heroic posture of self-destruction to him.

In this instance, as in others, the biographical motif or the anecdotal tradition works over and elaborates a piece of actual life experience; here, too, it seeks to offer, from the

16. There also exist stories of an architect committing suicide when he realizes that the work of another master is superior to his own (Sinninghe, 1943, no. 993; Thompson, 5:497).

viewpoint of the environment, a rationalistic explanation for the riddle of the artist's creative activity.

Biographical formula and life appear to be linked in two ways. Biographies record typical events, on the one hand, and thereby shape the typical fate of a particular professional class, on the other hand. The practitioner of the vocation to some extent submits to this typical fate or destiny. This effect relates by no means exclusively, or indeed primarily, to the conscious thought and behavior of the individual—in whom it may take the form of a particular "code of professional ethics"—but rather to the unconscious. The area of psychology to which we point may be circumscribed by the label of "enacted biography."

Bibliography

Adam, A. (1961), Der Teufel als Gottes Affe: Vorgeschichte eines Lutherwortes. *Luther-Jahrbuch*, 28:104–09.

Anderson, W. (1899), Japanese Artist, Kawanabi Kyosai. *The Studio*, 15:32.

Aretino, Pietro (1531), *Il primo libro delle lettere*, ed. F. Nicolini. 1913.

Armenini, G. B. (1587), *De' veri precetti della pittura*. Ravenna (facsimile reprint, Hildesheim, 1971).

Baldinucci, Filippo (1845–47), *Notizie dei professori del disegno da Cimabue in qua*, 5 vols. Florence.

Baltrusaitis, J. (1957), *Aberrations: Quatre essais sur la légende des formes*. Paris.

Bandello, M. (1554), *Novelle*. Milan: Giovanni Silvestri, 1813–1814.

Barbi, M. (1927), Una versione inedita della Novella del Grasso Legnaiuolo. *Studi di filologia italiana*, 1:133–44.

Barocchi, P. (1974), *Romanticismo storico*. Redazione del volume a cura di P.B., F. Nicolodi, S. Pinto. Florence.

Basset, R. (1906), Les Alixares de Grenade et le château de Khaouarnaq. *Revue Africaine*, 50:22–36.

Baudelaire, C. (1923), Quelques caricaturistes étrangers. *Oeuvres complètes*, 2:442. Paris.

Baudissin, K. von (1936), Rembrandts Tod als Fabel. *Wallraf-Richartz Jahrbuch*, 9.

Bellori, Gio. Pietro (1672), *Le vite de' pittori ecc*. Rome.

Benelli, Sem (1910), *La cena delle beffe*. Paris.

Bernheim, E. (1903), *Lehrbuch der historischen Methode*, 3rd & 4th eds. Leipzig.

Bianchi-Bandinelli, R. (1957), L'artista nell'antichità classica. *Archaeologia classica*, 9:1–17.

Bielefeld, E. (1953–54), *Aphrodite anadoumene paratheisa. Wissenschaftliche Zeitschrift der Universität Greifswald*, 3:107–10.

Birt, Theodor (1902), *Laienurteil über bildende Kunst bei den Alten.* Marburg (*Marburger Akademische Reden* 7).

Bittremieux, L. (1926), Overblÿfselen van den katholieken Godsdienst in Lager Kongoland. *Anthropos*, 21:797–805.

Boberg, I. M. (1955), *Baumeistersagen*. Helsinki (*Folklore Fellows Communications*, no. 151).

Bode, W. von and Volbach, W. F. (1918), Mittelrheinische Ton- und Steinmodel aus der ersten Hälfte des XV Jahrhunderts. *Jahrbuch der Königlich preussischen Kunstsammlungen*, 39:89–134.

Borinski, Karl (1914), *Die Antike in Poetik und Kunsttheorie*, vol. 1. Leipzig.

Bossert, H. Th. (1920), Eine gereimte Erzählung auf den Maler Konrad Witz. *Repertorium für Kunstwissenschaft*, 22:497ff.

Carpenter, Richard (1642), *Experience, Historie and Divinitie*. London.

Cassirer, Ernst (1925), *The Philosophy of Symbolic Forms*. New Haven: Yale University Press, 1955.

Casti, G. B. (1804), *Novelle*. Paris.

Chamberlain, A. B. (1913), *Hans Holbein the Younger*. London.

Chamisso, A. von (1836), *Gedichte*. Leipzig, 3rd ed.

Chavannes, Edouard (1910–11), *Cinq cents contes et apologues extraits du Tripitaka chinois et traduits en français*. Paris.

Ch'en Shih-hsiang (1948), Literature as Light against Darkness. *National Peking University Centennial*, papers no. 11. Revised edition published by Anthoesen Press, Portland, Maine, 1952.

Childs, N. (1967), Jacques Autreau. *Burlington Magazine*, 109:335–39.

Citralakshana, *see* Laufer (1913).

Cohn, William (1925), *Buddha in der Kunst des Ostens.* Leipzig.

Condivi, A. [ca. 1520], *Michelangelo: La Vita.* Revisione, introduzione e note per cura di P. d'Ancona. Milan, 1928.

Coomaraswamy, A. K. (1920), A Peacock's Feather. *Rupam*, 4:27.

—— (1931), *Yaksas*, vol. 2. Washington.

Corpus Hermeticum, ed. A. D. Nock, with French trans. by A.-J. Festugiere. Paris, 1945.

Coulton, G. G. (1912), Artistic Life in the Middle Ages. *Burlington Magazine*, 21:336.

Ćurčin, M. (1919), *Ivan Meštrović.* London.

Cuvreux, W. (1960), *Bibliotheca Orientalis*, 17:87f.

Dalitzsch, Max (1922), *Studien zur Geschichte der deutschen Anekdote.* Ms. thesis, Freiburg.

Dauw, Johann (1755), *Wohlunterrichteter und kunsterfahrener Schilderer und Maler.* [Probably] Copenhagen.

Der Nersessian, Sirarpie (1936), *Manuscrits arméniens illustrés de la XIIe, XIIIe, et XIVe siècles de la Bibliothèque des Pères Mekhitaristes de Venise.* Paris.

Diels, Hermann (1922), *Die Fragmente der Vorsokratiker.* 4th ed., Berlin.

Dobschütz, Ernst von (1899), *Christusbilder: Untersuchungen zur christlichen Legende.* Leipzig.

—— (1909), Das Schweisstuch der Veronica. Das Christusbild Abgars. Das Leichentuch Jesu. *Monatsschrift für Gottesdienst und kirchliche Kunst*, 14.

Domenichi, Lodovico (1563), *Detti e Fatti.* Venice.

Doni, A. E. (1928), *I Marmi*, ed. Ezie Chiòrboli, Bari.

Dornseiff, Fr. (1936), *Der sogenannte Apollon von Olympia.* Greifswald (*Greifswalder Beiträge*, Beiheft 1).

Du Gué Trapier (1940), *Eugenio Lucas y Padilla.* New York.

Eberhard, W. (1941), *Volksmärchen aus Südost-China.* Helsinki (*Folklore Fellows' Communications*, no. 128).

Eisler, Robert (1910), *Weltenmantel und Himmelszelt.* Munich.

Engelmann, R. (1904), Ein neues "Urtheil Salamonis" und die

Friesbilder der Casa Tiburiana. *Hermes,* 39:146–54.

Erasmus Roterodamus (1536), *Adagiorum chiliades.* Basle.

Erman, Adolf (1923), *Ägypten und ägyptisches Leben im Altertum,* ed. H. Ranke. Tübingen.

Fa-Hsien, *see* Giles (1956).

Feddersen, M. (1925), Über die Benutzung graphischer Vorbilder für die figürlichen Vorbilder auf japanischen Schwertzieraten. *Jahrbuch der asiatischen Kunst,* 2:28–33.

Filarete, Antonio Averlino detto [15th cent.], *Trattato di architettura.* Testo a cura di A. M. Finoli e L. Grassi. Milan, 1972.

Fischer, Otto (1912), Eine chinesische Kunsttheorie. *Repertorium für Kunstwissenschaft,* 35.

Floerke, Hans (1913), *Die fünfundsiebzig italienischen Künstlernovellen der Renaissance.* Munich.

Folena, G. (1953), Sulla tradizione dei "Detti piacevoli" attribuiti al Poliziano. *Studi di filologia italiana,* 11:431–48.

Förster, Ernst (1875), *Peter von Cornelius: Entwürfe zu den kunstgeschichtlichen Fresken in den Loggien der Königlichen Pinakothek zu München.* Leipzig.

Freud, Sigmund (1900), The Interpretation of Dreams. *Standard Edition,* vols. 4 & 5. London: Hogarth Press, 1953.

———— (1908), Creative Writers and Day-Dreaming. *Standard Edition,* 9:141–53. London, 1959.

———— (1909), Family Romances. *Standard Edition,* 9:235–41. London, 1959.

Frey, Carl (1892), *Il libro di Antonio Billi.* Berlin.

Fuhse, F. (1895), Zur Dürerforschung im 17. Jahrhundert. *Mitteilungen aus dem Germanischen Nationalmuseum.*

Fulgentius, Fabius Planciades (1543), *Mythologiarum libri XII (Unde idolum; Fabula Promethei).*

Geffcken, Johannes (1916–19), Der Bilderstreit des heidnischen Altertums. *Archiv für Religionswissenschaft,* 19:286–315.

Gelli, G. B. (1896), *Vite d'artisti* (ed. G. Mancini). *Archivio Storico Italiano,* 5th series, 17:32–62.

Gerlach, G. (1883), Über Mythenbildung in der alten Kunstge-

schichte. *l. Jahresbericht des Gymnasiums in Dessau*, pp. 1–22.

Gesta Romanorum, ed. H. Oesterley. Berlin, 1872.

Ghiberti, Lorenzo [c. 1378–1455], *I Commentarii*, edited and explained by J. von Schlosser. Berlin, 1912.

Giles, Herbert A. (1905), *An Introduction to the History of Chinese Pictorial Art*. Shanghai.

—— (1956), *The Travels of Fa-Hsien (399–414 A.D.)*, *a Record of the Buddhistic Kingdoms*. London.

Goethe, Johann W. (1800–16), Maximen und Reflexionen. *Weimarer Jubiläumsausgabe*, 48:177–286. Also in *Kunst und Altertum*.

—— (1932), *Viaggio in Italia*, ed. A. Farinelli. Rome.

Goldschmidt, Lazarus, ed. (1897ff.), *Der Babylonische Talmud*. Berlin.

Gombrich, E. H. and Kris, E. (1940), *Caricature*. London: King Penguin Books.

Gomperz, Heinrich (1905), Über einige psychologische Voraussetzungen der naturalischen Kunst. *Allgemeine Zeitung* (Munich), suppl. 160–61.

Gyllander, Hugo (1917), *Svenska Sägner*. Stockholm.

Habich, Georg (1920), Über zwei Prometheusbilder angeblich von Piero di Cosimo: Ein Deutungsversuch. *Sitzungsberichte der Bayr. Akademie d. Wiss. Philos.-philolog. u. hist. Kl.*, section 2.

Hackin, J. (1913), Sur des illustrations tibétaines d'une légende du Divyāvadāna. *Annales du Musée Guimet. Bibliothèque de vulgarisation*, 40:145–57.

Hampe, Th. (1928), Düreranekdoten. *Der neue Pflug*, 3:3ff.

Harris, Enriqueta (1969), *Goya*. London.

Hartmann, Alfred Georg (1917), *Das Künstlerwäldchen: Maler-, Bildhauer-, und Architektenanekdoten*. Berlin.

Haskell, F. (1971), The Old Masters in Nineteenth-Century French Painting. *Art Quarterly*, 34:55–85.

Hasluck, F. W. (1919), Prentice Pillars: The Architect and His Pupils. *Folklore*, 30:315.

Hempel, E. (1931), *Michael Pacher*. Vienna.

Hertslet, W. L. (1905), *Der Treppenwitz der Weltgeschichte*, 6th ed., ed. by H. F. Helmott. Berlin.

Herzfeld, Marie (1926), *Leonardo da Vinci, der Denker, Forscher und Poet.* Jena.

Hirth, Friedrich (1900), *Über Entstehung und Ursprungslegenden der Malerei in China.* Leipzig (offprint from *Allgemeine Zeitung*, suppl., nos. 117–18, May 22–23).

―――― (1905), *Scraps from a Collector's Note Book.* New York, pp. 373 ff.

Hoffmann, E. T. A. (1857), Die Doppelgänger. *Gesammelte Schriften*, 11/12. Berlin.

Hollanda, Francisco de [ca. 1548], *Four Dialogues on Painting*, tr. A. F. G. Bell. Oxford, 1928.

Houbraken, Arnold (1763), *De groote Schouburgh Nederlantsche Konstschilders en Schilderessen.* Amsterdam.

Huelsen, Ch. (1921), Von Aufrichtung des Obelisken: Eine römisch-byzantinische Frage. *Byzantinische-neugriechische Jahrbücher*, 2:453ff.

Ilg, A. (1871), Volksage und Kunstgeschichte. *Mittheilungen der Central-Commission*, p. cxlviii.

―――― (1881), *Zeitstimmen über Kunst und Künstler.* Vienna.

James, M. R. (1924), *The Apocryphal New Testament . . . newly translated.* Oxford.

Janson, H. W. (1961), The "Image Made by Chance" in Renaissance Thought. *De artibus opuscula XL: Essays in Honor of Erwin Panofsky.* New York, pp. 254–66.

Jeremias, Alfred (1930), *Das Alte Testament im Lichte des alten Orients*, 4th ed. Leipzig.

Junker, H. (1960), Die gesellschaftliche Stellung der ägyptischen Künstler im Alten Reich. *Sitzungsberichte der Österreichischen Akademie der Wissenschaften*, 233:1–98.

Kaibel, G. (1901), *Daktyloi Idaioi. Nachrichten von der kgl. Gesellsch. d. Wiss. zu Göttingen. Philos.-hist Kl.*, pp. 488ff.

Kalkmann, A. (1898), *Die Quellen der Kunstgeschichte des Plinius.* Berlin.

Kallab, W. (1908), *Vasaristudien*. Vienna.

Kant, I. (1781), *Critique of Pure Reason*, tr. N. K. Smith. London: Macmillan, 1929.

Kehrer, Hugo (1918), *Francisco de Zurbarán*. Munich.

―――― (1923), Ein Besuch des Giulio Clovio im Atelier Grecos. *Kunstchronik* (New Series 34), 58:784f.

―――― (*n.d.*), *Francisco de Goya*. Munich.

Kennedy, R. W. (1964), *Apelles redivivus*: *Essays in Memory of Karl Lehmann*. New York, pp. 160–70.

Keyssler, J. G. (1740–41), *Neueste Reise & Fortsetzung neuster Reisen*. Hanover. Tr. as: J. G. Keysler, *Travels*. London, 3rd ed., 1760.

Kinkel, Gottfried (1876), *Mosaik zur Kunstgeschichte*. Berlin ("Sagen aus Kunstwerken enstanden," pp. 161ff.).

Klauner, F. (1964), Ein Planetenbild von Dosso Dossi. *Jahrbuch der Kunsthistorischen Sammlungen in Wien*, 40:137–60.

Köhler, R. (1898–1900), *Kleinere Schriften*, 3 vols., ed. J. Bolte. Berlin.

Kris, Ernst (1926), Der Stil "rustique": Die Verwendung des Naturabgusses bei Wenzel Jamnitzer und Bernard Palissy. *Jahrbuch der Kunsthistorischen Sammlungen in Wien*, 1:137–208.

―――― (1929), *Meister und Meisterwerke der Steinschneidekunst in der italienischen Renaissance*. Vienna.

―――― (1932), Die Charakterköpfe des Franz Xaver Messerschmidt. *Jahrbuch Kunsthistorisches Museum* (Vienna), 6:169–228.

―――― (1933), Ein geisteskranker Bildhauer. *Imago*, 19:384–411, *See also* chapter 4 in Kris (1952).

―――― (1934), The Psychology of Caricature. *International Journal of Psycho-Analysis*, 17:285–303. *See also* chapter 6 in Kris (1952).

―――― (1935), Zur Psychologie älteren Biographik: dargestellt an der des bildenden Künstlers. *Imago*, 21:320–44.

―――― (1952), *Psychoanalytic Explorations in Art*. New York.

―――― and Gombrich, E. H. (1938), The Principles of Caricature. *British Journal of Medical Psychology*, 17:319–342. *See also* chap-

ter 7 in Kris (1952).

Kristeller, P. O. (1951–52), The Modern System of the Arts: A Study in the History of Aesthetics. *Journal of the History of Ideas*, 12:496–527; 13:17–46.

Ku Teng (1932), Su Tung P'o als Kunstkritiker. *Ostasiatische Zeitschrift*, 8:104–10.

Kurz, Otto (1933), Zu Vasaris Vita des Fra Filippo Lippi. *Mitteilungen d. österr. Instituts f. Geschichtsforschung*, 47.

Lagerlöf, Selma (1908), *Christ Legends*. New York, Henry Holt.

Lalo, Charles (1933), *L'expression de la vie dans l'art*. Paris.

Lane, G. S. (1947), The Tocharian Punyavantajataka [text and translation]. *Journal of the American Oriental Society*, 67:33–53.

Las Casas, B. de (1919), *Apologetica historia de las Indias*. Madrid (*Nueva Biblioteca de Autores Españoles*, 13).

Laufer, B. (1913), *Das Citralakshana*, nach dem tibetischen Tanjur herausgegeben und übersetzt. Leipzig.

Lecomte, Georges (1913), David et ses élèves. *Les Arts*, no. 142.

Leonardo da Vinci, *The Literary Works*, compiled and edited by J. P. Richter. Oxford, 2nd ed., 1939.

———— *Treatise on Painting* (*Codex Urbinas latinus 1270*), translated and annotated by A. Philip McMahon. Princeton, 1956.

Levey, M. (1959), *Painting in XVIII Century Venice*. London.

Levitine, G. (1958), Addenda to R. Rosenblum's *The Origin of Painting*. *Art Bulletin*, 40:329–31.

Leyen, Friedrich von der (1917), *Das Märchen*. Leipzig, 2nd ed.

Liebrecht, Felix (1879), *Zur Volkskunde: Alte und Neue Aufsätze*. Heilbronn.

Lindner, Arthur (1903), *Danzig*. Leipzig (*Berühmte Kunststätten*, vol. 19).

Löbell, Johann Wilhelm (1859), Das reale und das ideale Element in der geschichtlichen Überlieferung und Darstellung. *Historische Zeitschrift*, 1:269ff.

Loga, Valerian von (1903), *Francisco de Goya*. Berlin.

McCown, C. C., ed. (1922), *The Testament of Solomon*. Leipzig: J. C. Hinrichs.

Malvasia, Carlo Cesare (1841), *La Felsina pittrice*. Bologna, 2nd ed.

Mander, Carel van (1906), *Dutch and Flemish Painters*, tr. C. van de Wall. New York, 1936.

Mann, Thomas (1948), The Infant Prodigy. *Stories of Three Decades*. New York: Knopf.

Mannhardt, W. (1875), Die Lettischen Sonnenmythen ("Der Himmelschmied"). *Zeitschrift für Ethnologie*, 7:318ff.

Mayer, L. A. (1956), *Islamic Architects and Their Works*. Geneva.

Mayers, W. F. (1874), *The Chinese Reader's Manual*. Reprinted London/Shanghai, 1910.

Messerschmidt, Franz Xaver (1794), *Merkwürdige Lebensgeschichte des* ... Vienna. See also Kris (1933).

Millais, J. G. (1899), *The Life and Letters of Sir John Everett Millais*. London.

Misson, M. (1698), *Nouveau voyage d'Italie*. The Hague, 3rd ed.

Monnier, Philipp (1928), *Venedig im 18. Jahrhundert*. Munich.

Mordtmann, J. H. (1922), Das Ei des Columbus. *Der Islam*, 12:190ff. (addendum, 257).

Münzer, F. (1895), Zur Kunstgeschichte des Plinius. *Hermes*, 30:498–547.

———— (1899), Review of Kalkmann [1894], *Göttingische gelehrte Anzeigen*, 161:975–84.

Musper, Th. (1935), Das Reiseskizzenbuch von Josef Anton Koch aus dem Jahre 1791. *Jahrbuch der preussischen Kunstsammlungen*, 61:167–93.

Nagler, G. K. (1835–52), *Neues allgemeines Künstler-Lexicon*. Munich.

Nebesky-Wojkowitz, R. de (1953), Die Legende vom Turmbau der Lepcha. *Anthropos*, 48:889–97.

Nersessian, *see* Der Nersessian.

Neumann, C. (1927), Rembrandt-Legende. *Festschrift für Max J. Friedländer*. Leipzig, pp. 161ff.

Nicodemi, G. (1931), Daniele Crespi. *Emporium*, 73:26.

Noe, H. (1954), *Carel van Mander en Italie*. The Hague.

Normann, F. (1925), Mythos und Kunstgeschichte. *Belvedere*

(First Biannual Forum), pp. 45–48.

Odenius, O. (1957), The Painter and the Devil: Notes from Legendary History on a Marian Miracle. *Arv. Tidskrift för Nordisk Folkminnesforskning*, 13:111–58.

Otto, W. F. (1956), *Die Musen und der göttliche Ursprung des Singers und Sagens.* Darmstadt.

Overbeck, J. (1868), *Die antiken Schriftquellen zur Geschichte der bildenden Künste bei den Griechen.* Leipzig.

Pacioli, Luca (d. 1514), *De viribus quantitatis.*

Palomino, A. (1947), *El museo pictórico y escala optica* (1715–24). Madrid.

Panofsky, Erwin (1921–22), Die Michelangelo-Literatur seit 1914. *Jahrbuch für Kunstgeschichte*, suppl., pp. 1ff.

——— (1924), *Idea: Ein Beitrag zur Begriffsgeschichte der älteren Kunsttheorie.* Leipzig (*Studien der Bibliothek Warburg*, V). English tr. by Joseph Peake, London, 1961.

——— (1953), *Early Netherlandish Painting: Its Origin and Character.* Cambridge, Mass.

Panzer, F. (1930), Zur Wielandsage. *Zeitschrift für Volkskunde* (New Series II), 40:125–35.

Passeri, Giovanni B. (1772), *Vite de' pittori, scultori ed architetti.* Rome.

Pauli, J. (1924), *Schimpf und Ernst*, 2 vols., ed. Johannes Bolte. Berlin.

Paulys Realenzyklopädie der klassischen Altertumswissenschaft. New ed. by G. Wissowa. Stuttgart, 1894ff.

Pigler, A. (1957), Portraying the Dead. *Acta historiae artium Academiae Scientiarum Hungaricae*, 4:1–75.

Piles, R. de (1715), *Abregé de la vie des peintres.* Paris, 2nd ed.

Planiscig, Leo (1910), Artisti contemporanei: Ivan Meštrović. *Emporium*, 31:323.

Pliny, *see* Sellers (1896).

(Poimandres), *Le Pimandre d'Hermès Trismégiste.* Dialogues gnostiques traduits de que par Georges Gabory. Paris, 1920.

Polo, Marco, *The Description of the World*, tr. A. C. Moule.

London, 1938.

Pöschel, Hans (1925), *Kunst und Künstler im antiken Urteil.* Munich.

Puhvel, M. (1961), The Legend of the Church-Building Troll in Northern Europe. *Folklore,* 71–72:567–83.

Rank, Otto (1909), *The Myth of the Birth of the Hero.* New York, 1913.

Reinach, S. (1917), Apelles et le cheval d'Alexandre. *Revue archéologique,* 5:189–97.

Reuterswärd, P. (1956), Tavelförhänget. *Konsthistorisk Tidskrift,* 25:95–113 (with English summary).

Richter, J. P., *see* Leonardo.

Ridolfi, Carlo (1914, 1924), *Le maraviglie dell'arte,* 2 vols., ed. D. von Hadeln. Berlin.

Robert, Carl (1886), *Archäologische Märchen aus alter und neuer Zeit.* Berlin.

—— (1909), Pausanias als Schriftsteller. *Studien und Beobachtungen.* Berlin.

—— (1914), Pandora. *Hermes,* 49:17ff.

Roessler, Arthur (1924), *Der Malkasten: Künstler-Anekdoten.* Leipzig & Vienna.

Roscher, W. H. (1884ff.), *Ausführliches Lexikon der griechischen und römischen Mythology.* Leipzig.

Rosenblum, R. (1957), The Origin of Painting: A Problem in the Iconography of Romantic Classicism. *Art Bulletin,* 39:279–90.

Rosenfeld, H. (1935), C. F. Meyers "Nach einem Niederländer" und das Problem künstlerischer Gestaltung. *Germanisch-romanische Monatsschrift,* 23:467–90.

Rumohr, C. F. von (1835), *Novellen* II. Munich.

Rösiger, F. (1880), *Die Bedeutung der Tyche bei den späteren griechischen Historikern.* Konstanz.

—— (1920), *Italienische Forschungen,* ed. Julius von Schlosser. Frankfurt-am-Main.

Sacchetti, F. [ca. 1330–1400], *Cento Novelle,* scelti e commentate da R. Fornaciari. Florence: Sansoni, 1921.

Sandrart, J. von (1925), *Academie der Bau-, Bild- und Mahlerei-Künste von 1675*, ed. with commentary by A. R. Peltzer. Munich.

Sauer, B. (1917–18), Favorinus als Gewährsmann in Kunstdingen. *Rheinisches Museum für Philologie* (new series LXII), pp. 527–36.

Scheurl, Christoph (1508), *Libellus de laudibus Germanie*, 2nd. ed.

Schick, J. (1934), *Corpus Hamleticum*, section 1, vol. 4, part 1: *Die Scharfsinnsproben*. Leipzig.

Schlegel, Erich (1915), *Paracelsus als Prophet*. Tübingen.

Schlosser, Julius von (1892), *Schriftquellen zur Geschichte der karolingischen Kunst*. Vienna.

———— (1896), *Quellenbuch zur Kunstgeschichte des abendländischen Mittelalters*. Vienna.

———— (1924), *Die Kunstliteratur: Ein Handbuch zur Quellenkunde der neueren Kunstgeschichte*. Vienna.

———— (1927), *Präludien: Vorträge und Aufsätze*. Berlin.

Schmidt, R., tr. (1913), *Sukasaptati*. Munich.

Schmidt, [Father] Wilhelm (1926), *The Origin and Growth of Religion*, tr. H. J. Rose. London: Methuen, 1931.

———— & Koppers, W. (1924), *Völker und Kulturen*. Regensburg: Josef Habbel.

Schnabel, Paul (1923), *Berossos und die babylonisch-hellenistische Literatur*. Leipzig & Berlin.

Schwarz, Paul (1921), *Iran im Mittelalter nach den arabischen Geographen*, vols. 4 & 5. Leipzig.

Schweitzer, Bernhard (1925), Der bildende Künstler und der Begriff des Künstlerischen in der Antike. Mimesis und Phantasia: Eine Studie. *Neue Heidelberger Jahrbücher*.

Segantini, Gottardo (1923), *Giovanni Segantini: Sein Leben und seine Werke*. Munich, 5th ed.

Sellers, E., ed. (1896). *The Elder Pliny's Chapters on the History of Art*, tr. by K. Jex-Blake. London.

Seneca, Lucius [ca. 3 B.C.–65 A.D.], *Controversiae*. Venice, 1942.

Servaes, Franz (1902), *Giovanni Segantini: Sein Leben und sein*

Werk. Vienna.

Sieg, E. (1919–20), Das Märchen von dem Mechaniker und dem Maler in tocharischer Fassung. *Ostasiatische Zeitschrift*, 8:362ff.

—— (1944), Übersetzungen aus dem Tocharischen I. *Abhandlungen der Preussischen Akademie der Wissenschaften 1943*, no. 16.

Singer, Samuel (1939), *Wolfram und der Gral: Neue Parzival-Studien.* Bern (*Schriften der Literarischen Gesellschaft Bern*, 2).

Sinninghe, J. R. W. (1943), *Katalog der niederländischen Märchen- und Ursprungssagen, Sagen- und Legendenvarianten.* Helsinki (*Folklore Fellows Communications*, no. 132).

Smith, John Thomas (1949), *Nollekens and His Times*, ed. G. W. Stonier. London.

Soper, Alexander C. (1949–50), Aspects of Light Symbolism in Gandhara Sculpture. *Artibus Asiae*, 12:252–83; 13:63–85.

Steinmann, E. & Wittkower, R. (1927), *Michelangelo-Bibliographie 1510–1926.* Leipzig (*Römische Forschungen der Bibl. Hertziana* I).

Stirling-Maxwell, W. (1891), *Annals of the Artists of Spain.* London, new ed.

Strange, E. F. (1906), *Hokusai: The Old Man Mad with Painting.* London.

Stummer, F. (1944), Bemerkungen zum Götzenbuch des Ibn al-Kalbi. *Zeitschrift der Deutschen Morgenländischen Gesellschaft*, 98:377–94.

Sukasaptati: Das indische Papageienbuch. Aus dem Sanskrit übersetzt von Richard Schmidt. Munich, 1913.

Talos, I. (1969), Baumeistersagen in Rumänien. *Fabula*, 10:196–211.

The Testament of Solomon, see McCown (1922).

Thieme-Becker (1907ff.), *Allgemeines Lexikon der bildenden Künstler.* Leipzig.

Thode, Henry (1908), *Michelangelo und das Ende der Renaissance*, IV. Berlin.

Thompson, Stith (1955–58), *Motif-Index of Folk-Literature*, 6 vols. Copenhagen, rev. ed.

Tubach, F. C. (1969), *Index Exemplorum: A Handbook of Medieval Religious Tales.* Helsinki (*Folklore Fellows Communications,* no. 204).

Van de Waal, H. (1967), The *Linea summae tenuitatis* of Apelles: Pliny's Phrase and Its Interpreters. *Zeitschrift für Ästhetik und allgemeine Kunstwissenschaft,* 12:5–32.

Varese, C. (1955), *Prosatori volgari del Quattrocento.* Milan & Naples.

Vasari, Giorgio [1550], *Vite de piu eccellenti pittori, scultori, ed architetti,* 9 vols. Con nuove annotazioni e commenti di G. Milanesi. Florence, 1878–85.

Veckenstedt, E. (1883), *Die Mythe, Sagen und Legenden der Zamaiten (Litauer).* Heidelberg.

Venturi, L. (1924), Pietro Aretino e Giorgio Vasari. *Mélanges Bertaux.* Paris.

Voss, H. (1920), *Die Malerei der Spätrenaissance in Rom und Florenz.* Berlin.

Vossler, K. (1909), *Medieval Culture: An Introduction to Dante and His Times,* tr. W. C. Lawton. New York: Harcourt, Brace, 1929.

Warburg, A. (1932), Die Erneuerung der heidnischen Antike. *Kulturwissenschaftliche Beiträge zur Geschichte der europäischen Renaissance.* Leipzig & Berlin.

Wegner, M. (1929), Ikonographie des chinesischen Maitreya. *Ostasiatische Zeitschrift,* new series V.

Weixlgärtner, A. (1928), Die Fliege auf dem Rosenkranzfest. *Mitteilungen der Gesellschaft für vervielfältigende Kunst,* pp. 20–22.

Wesselski, Albert (1929), *Angelo Polizianos Tagebuch.* Zum erstenmale herausgegeben. Jena.

Whitley, W. T. (1928), *Artists and Their Friends in England 1700–1799.* London.

Wickhoff, Franz (1889), Über die Zeit des Guido von Siena. *Mitteilungen des Institute für österreichische Geschichtsforschung,* 10:244–86.

Wieland, C. M. (1857), Anekdoten aus der Kunstgeschichte. *Sämmtliche Werke*, 35:223–26. Leipzig & Göschen.

Wille, H. (1960), Die Erfindung der Zeichenkunst. *Beiträge zur Kunstgeschichte: Eine Festgabe für H. R. Rosemann*. Munich, pp. 279–300.

Winner, M. (1962), Gemalte Kunsttheorie: Zu Gustav Courbets "Allégorie réelle" und der Tradition. *Jahrbuch der Berliner Museen*, 4:150–85.

Wurzbach, Alfred von (1906ff.), *Niederländisches Künstler-Lexicon*. Vienna & Leipzig.

Zilsel, Edgar (1926), *Die Entstehung des Geniebegriffes: Ein Beitrag zur Ideengeschichte der Antike und des Frühkapitalismus*. Tübingen.

Zimmer, H. (1955), *The Art of Indian Asia: Its Mythology and Transformations*. New York.

Zuccaro, Federigo (1607), *L'idea de' pittori, scultori ed architetti*. Turin. Facsimile reprint ed. D. Heikamp, Florence, 1961.

Index